Fashion
DOODLES

Fashion DOODLES

Robyn Neild

ARCTURUS

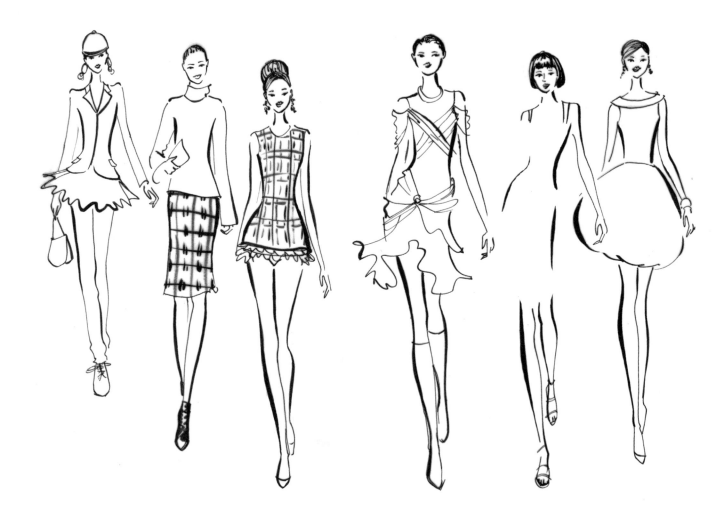

ARCTURUS

This edition published in 2016 by Arcturus Publishing Limited
26/27 Bickels Yard, 151–153 Bermondsey Street,
London SE1 3HA

ISBN: 978-1-78212-963-9
CH004050NT

Printed in China

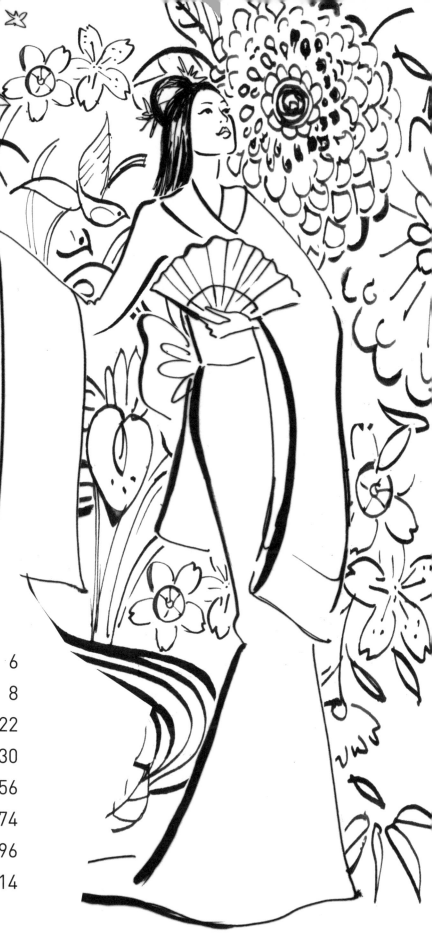

CONTENTS

Fashion is everywhere to be seen, whether you are walking through a modern cityscape, shopping in a town, visiting the movies or looking at your own scrapbook. All things creative can inspire fashion!

This book will help you to bring your fabulous doodles to fruition. The following pages are packed with sophisticated, beautiful illustrations, specially drawn by international fashion illustrator Robyn Neild, offering a feast of style and imagination for fashion divas of all ages.

What is your preferred drawing medium?

When you start sketching and doodling, it's important to pick the right materials to suit your subject matter. You can doodle with pencil, biro, marker pen, crayon, pastel or collage, whichever you feel most comfortable using. To enhance the scenes, you can add to the background, tones, patterns, characters and dresses. It's important to choose the right tools to create the best images.

Pencil

Before trying out the more permanent media, such as pen and ink, you may wish to start your doodles using a selection of pencils, as these marks can be erased easily. Graphite pencils are wonderful to sketch and doodle with. Each pencil has the degree of hardness printed on it – 9H to 1H are the hardest, for light marking, HB is the middle of the range, and 1B to 6B are the softest, for heavy, dark lines. Pencil is good for adding subtle shading, giving depth and texture to your images. Make sure to keep your pencils sharp for good, strong lines.

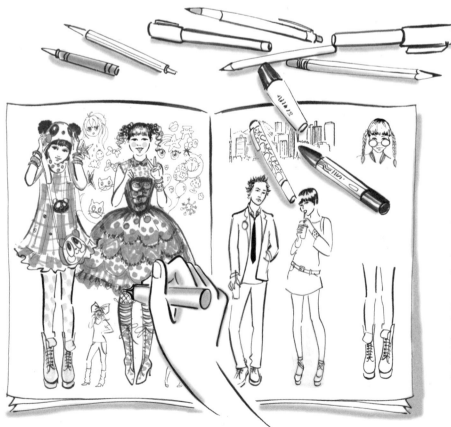

Pen and ink

Loose, quick sketches require a good flow of ink from either a fine brush (ideally a Chinese brush) or a dipping pen with a nib. The strokes should be light and flowing and you should be prepared for 'happy accidents' – unintended marks that can enhance your picture.

Perhaps a felt pen or marker is better suited to you? Try several thicknesses until you find your ideal marker. Ballpoint or graphic pens, such as the Rotring range with nibs

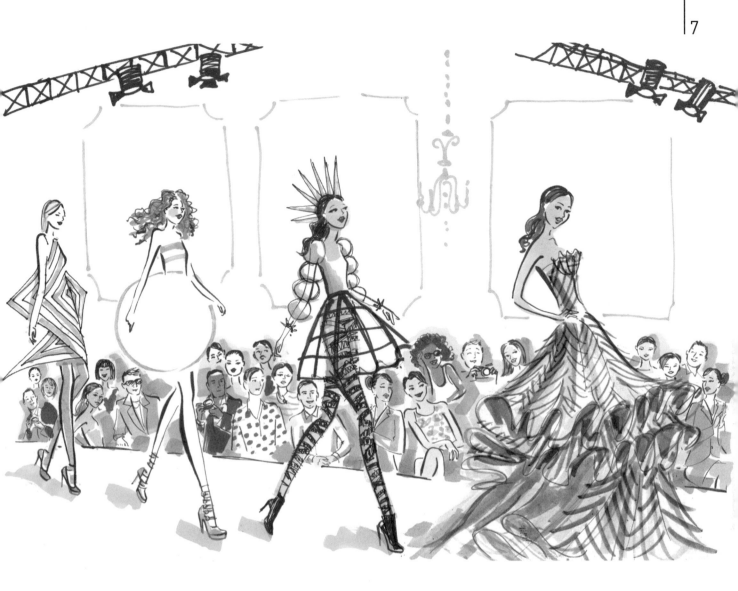

of different widths, will give you fine, regular lines which makes images tighter, cleaner and easier to control.

Working up your style

Once you've developed some confidence, start exploring with crayons, oil pastels and soft pastels. Now use your imagination to decorate, tint, shade and create unique slick dresses, catwalk creations, hats to die for, killer heels, beautiful bags and other dazzling accessories.

The following pages contain fashion figures and unfinished sketches to which you can add your own ideas. In this way, you will enhance your drawing skills and discover interesting shapes and forms that can be worked up into your own personal masterpieces.

In the Catwalk section (see pages 94–5), you can become a fashion designer and draw your own capsule collection on the four models, or you can make each model stand out with an individual look, for example, gothic, red carpet couture, romantic, Fifties floral – you choose! Be inspired, create your own unique style and let your imagination guide you.

Don't just DO fashion

. . . BE fashion!

out and
about in
London

New York City chic

Parisian couture

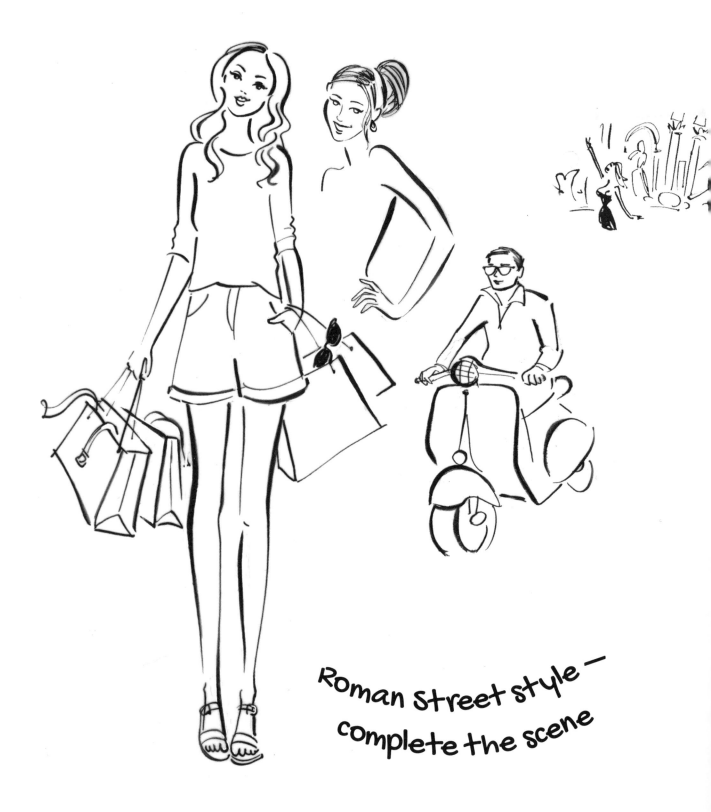

Roman street style— complete the scene

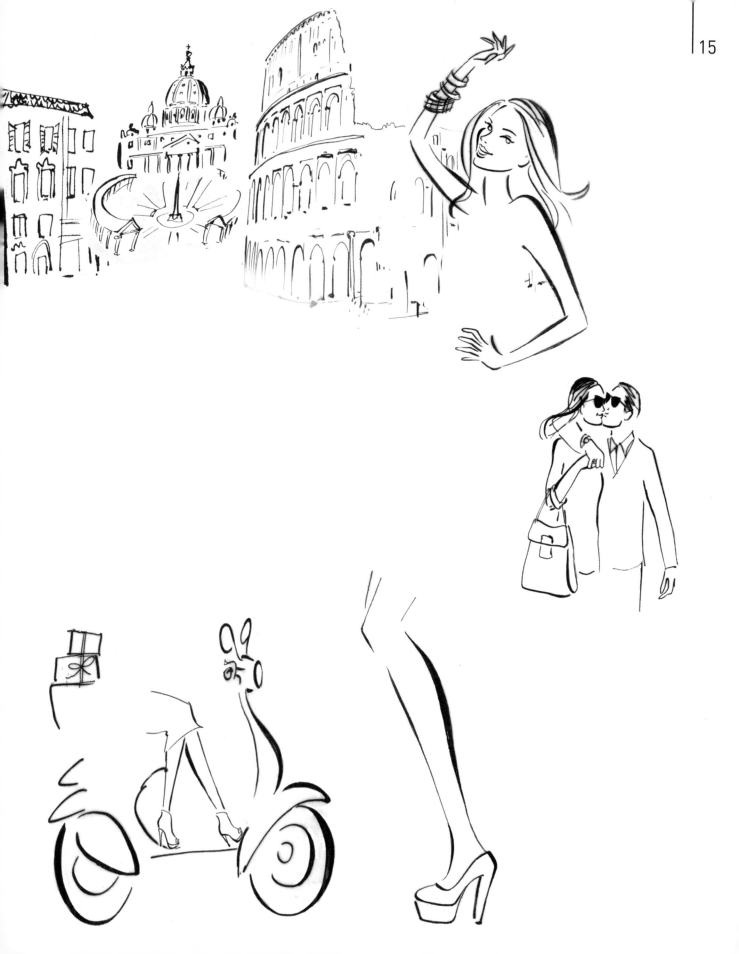

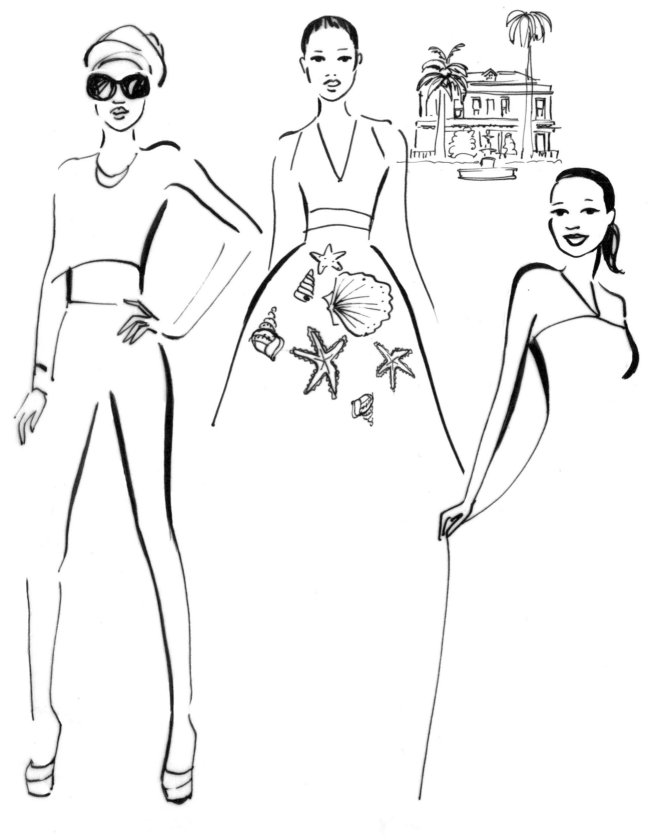

Stay cool and chic
in the
heat of Havana!

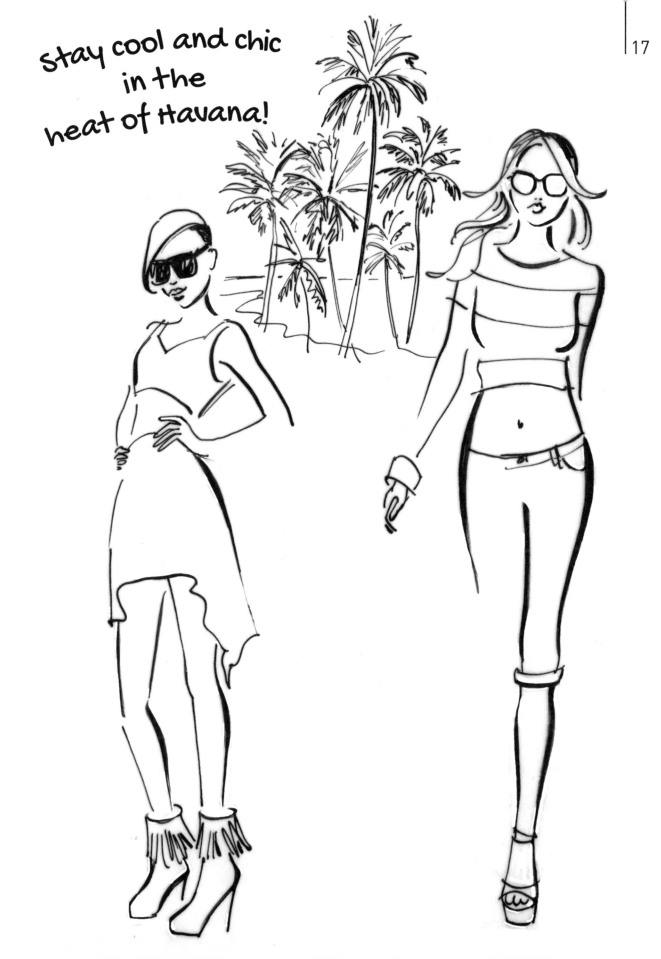

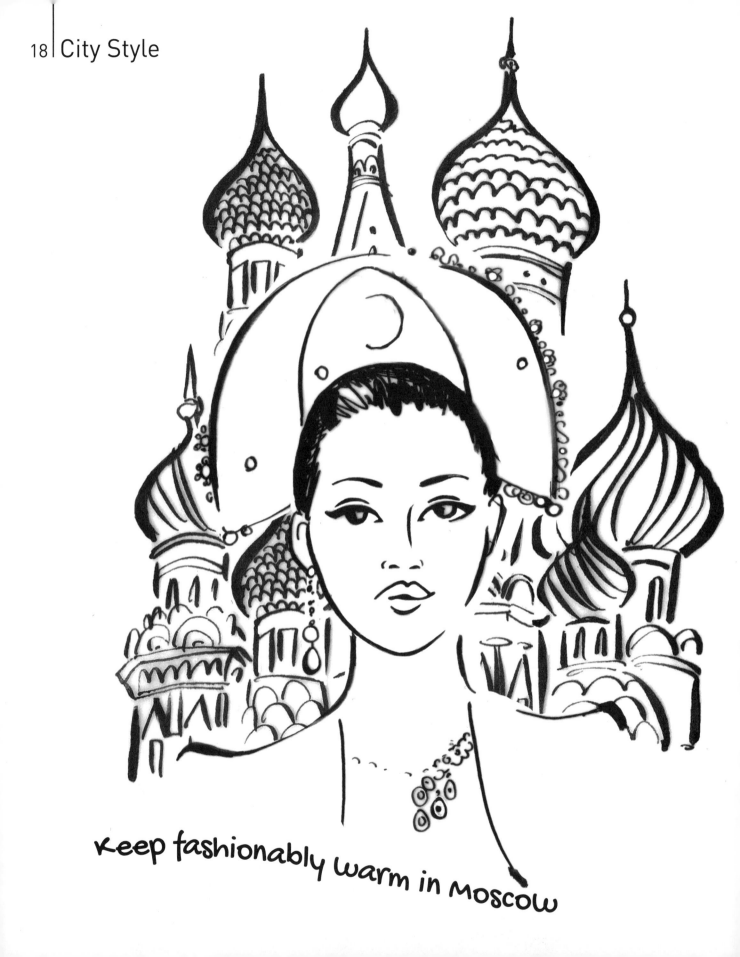

Keep fashionably warm in Moscow

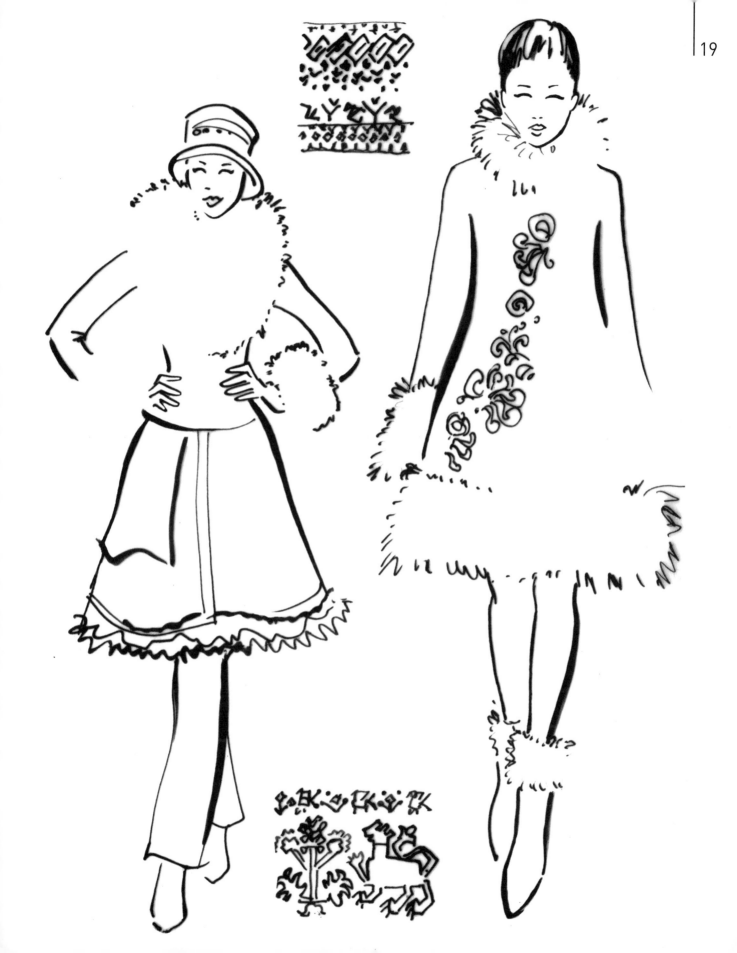

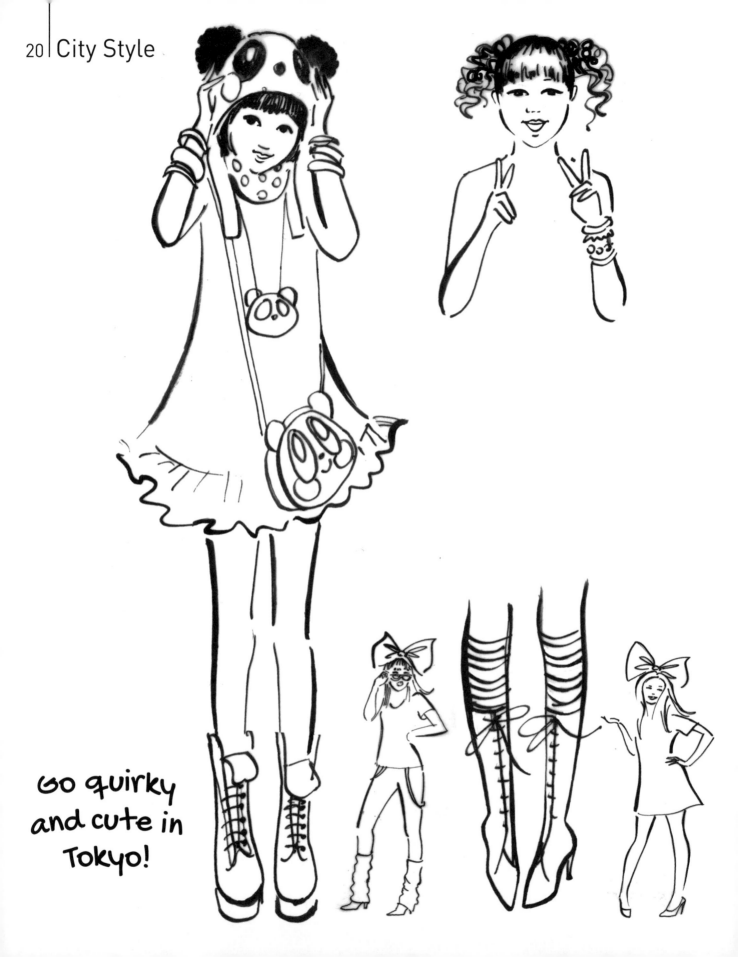

Go quirky and cute in Tokyo!

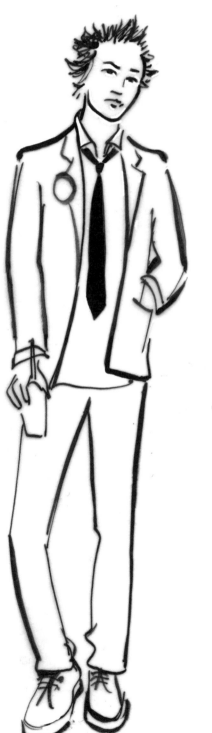

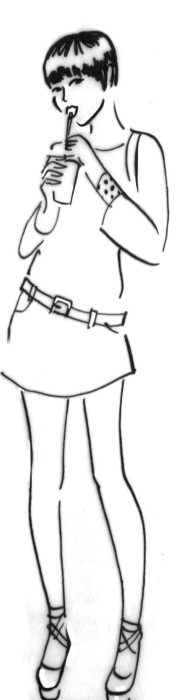

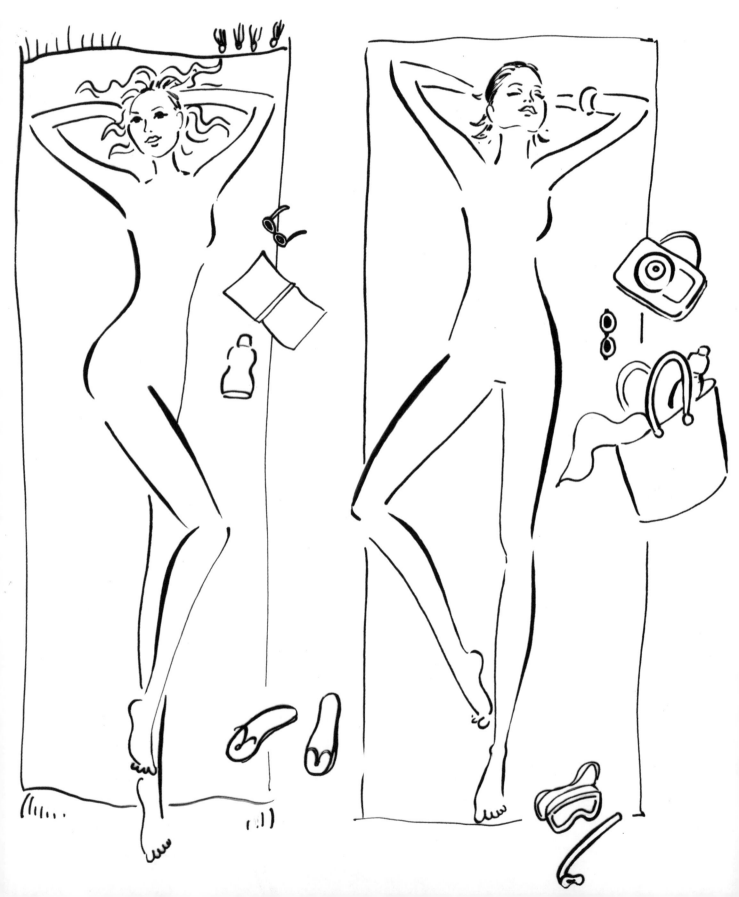

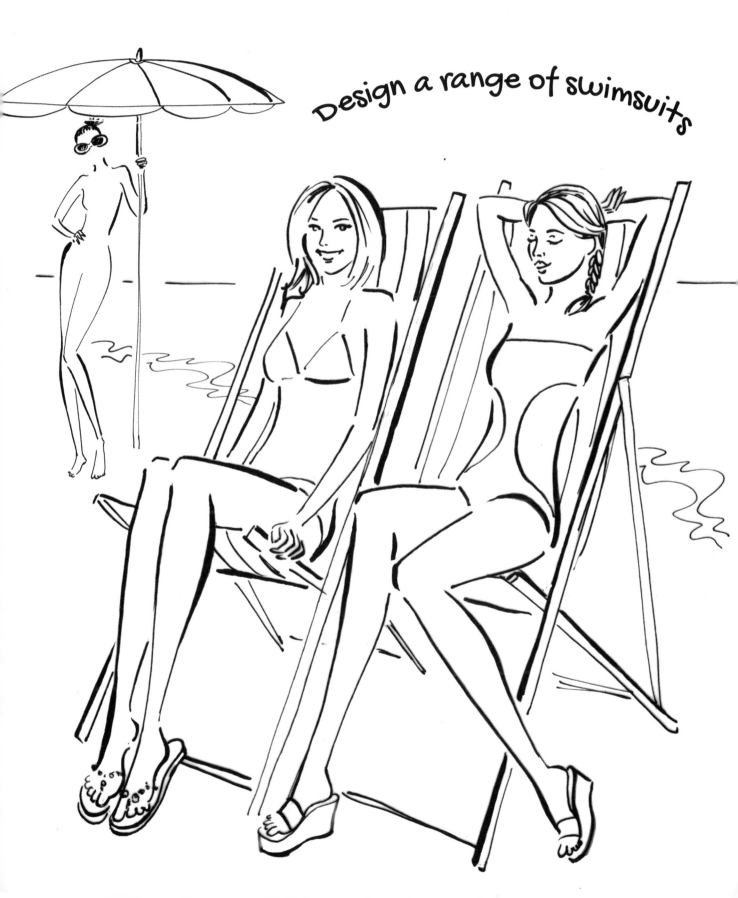

Design a range of swimsuits

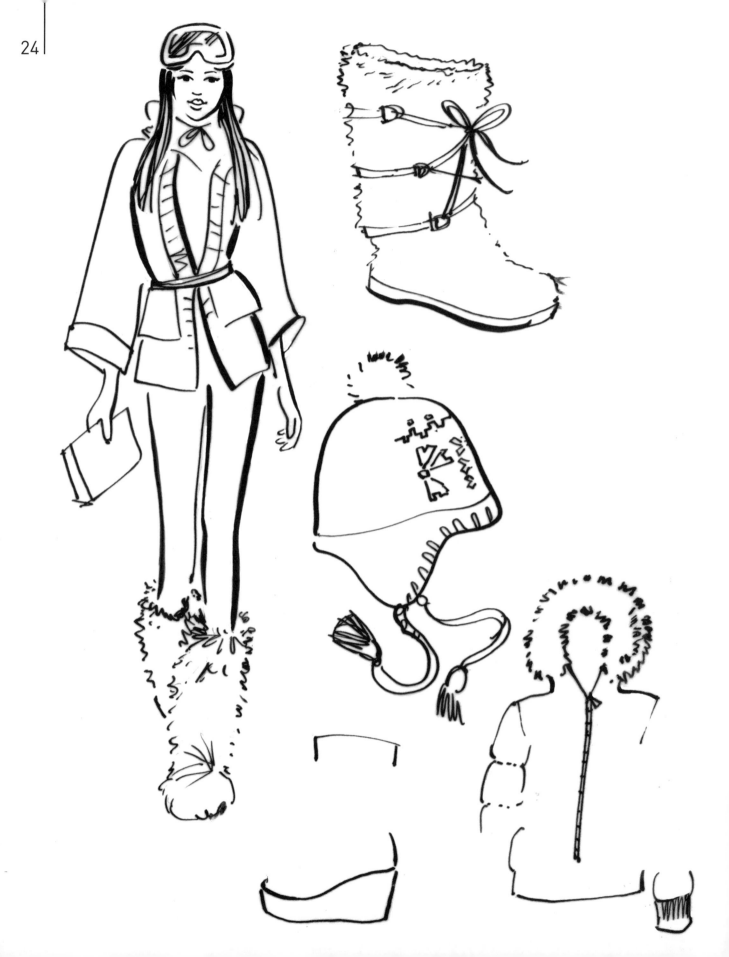

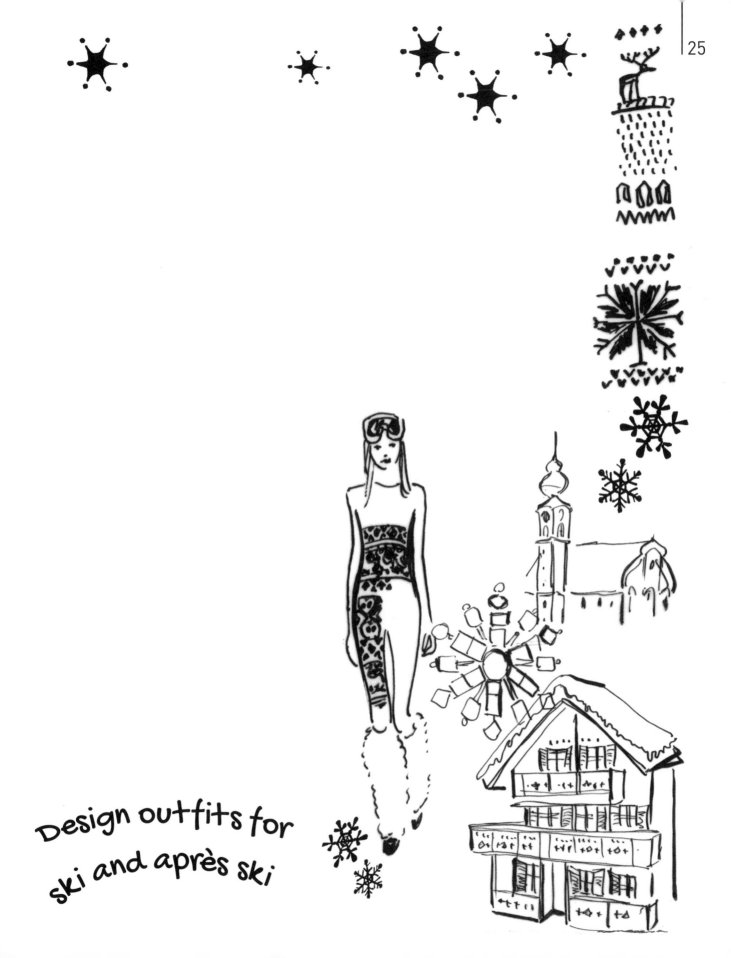

Design outfits for
ski and après ski

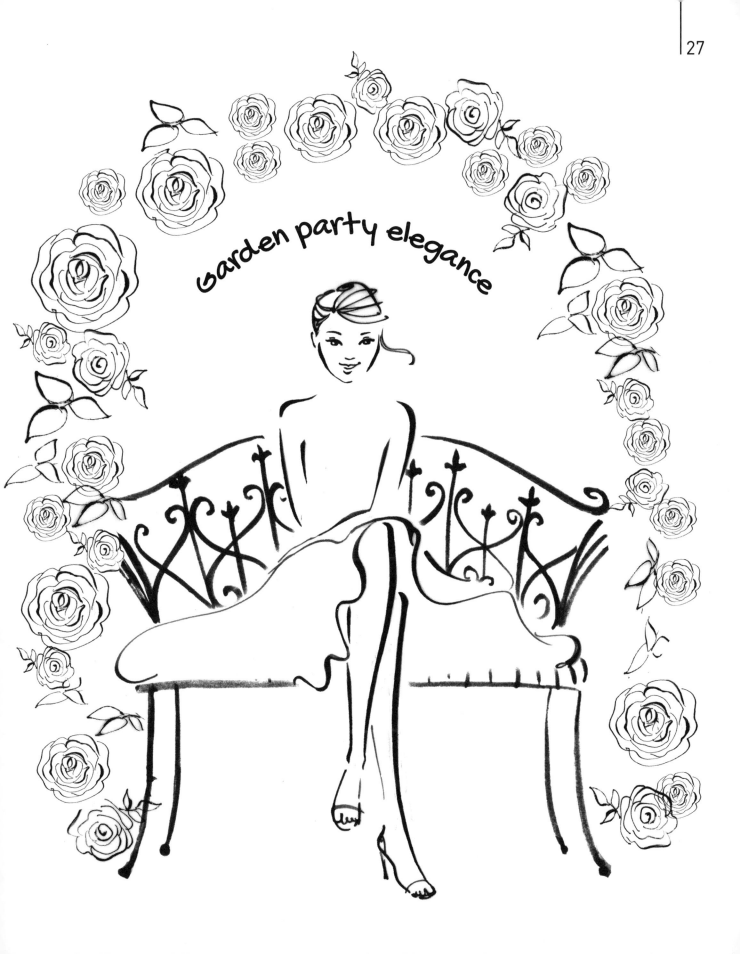

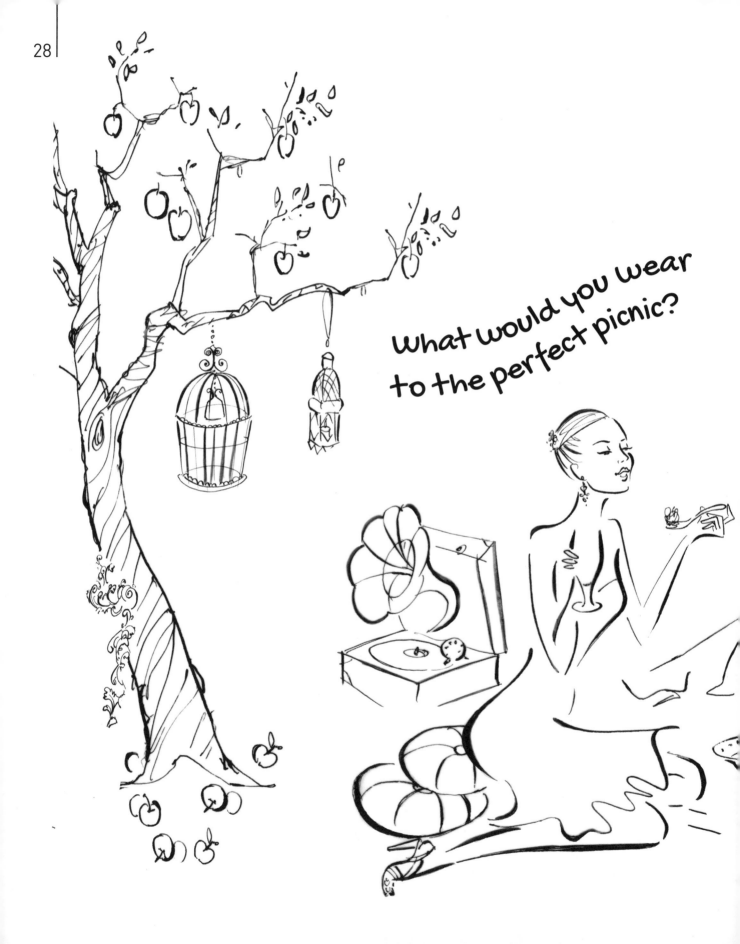

What would you wear to the perfect picnic?

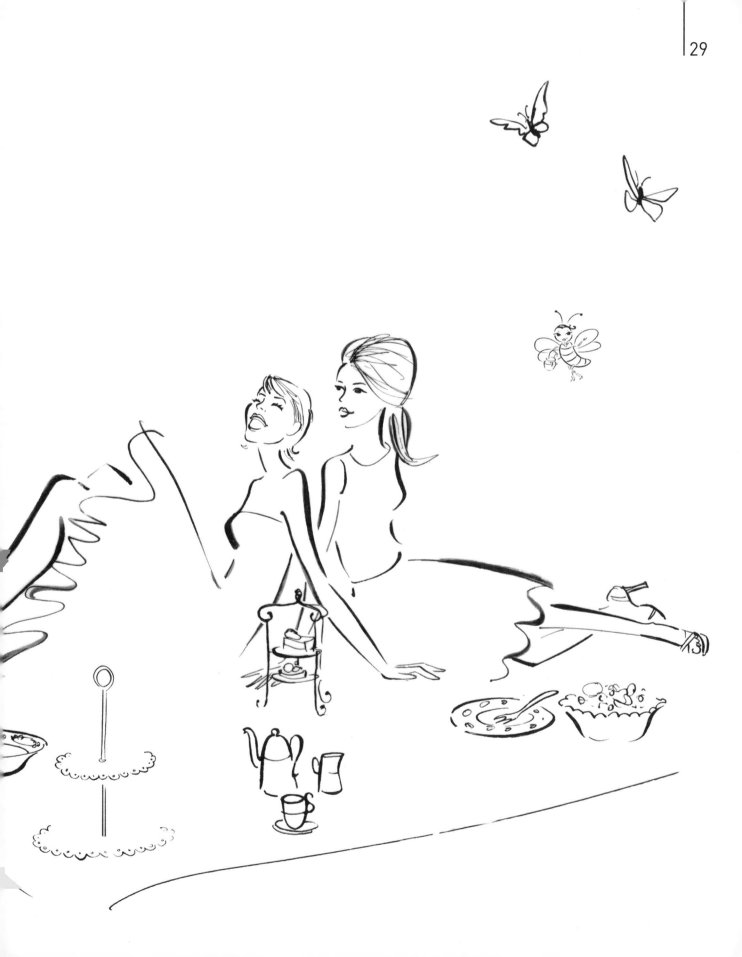

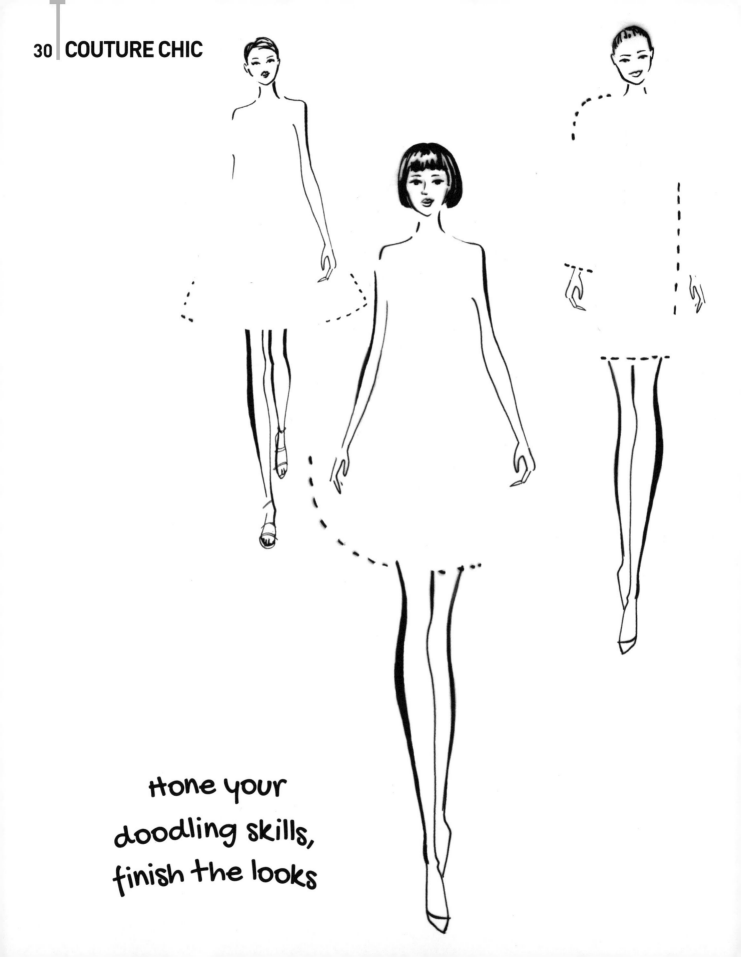

Hone your
doodling skills,
finish the looks

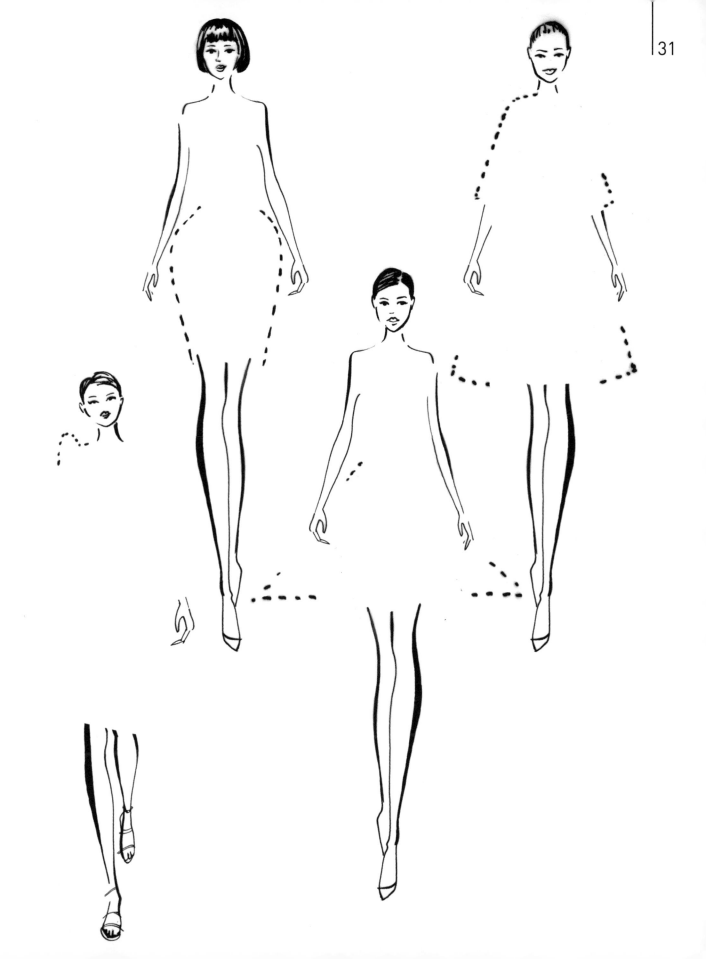

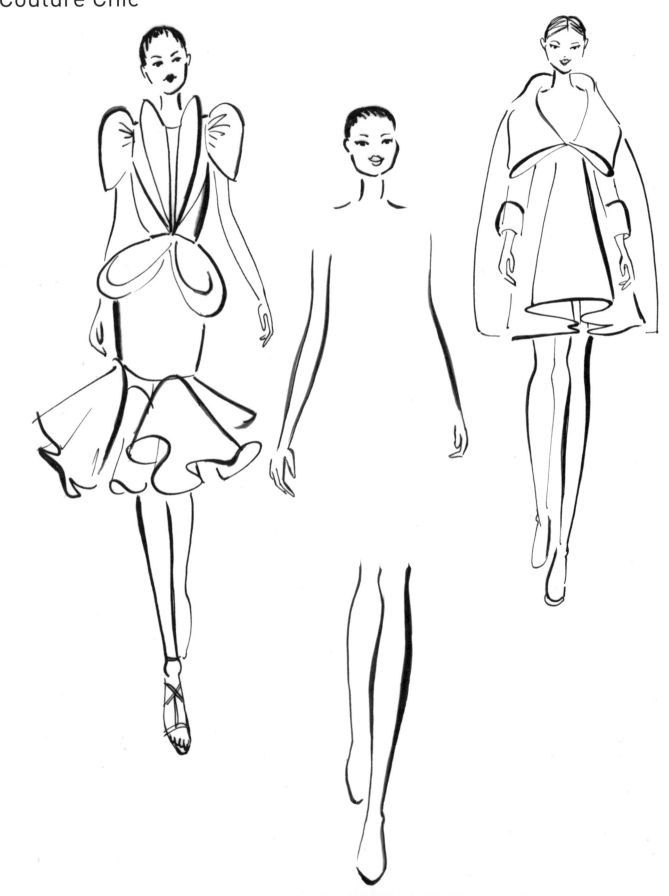

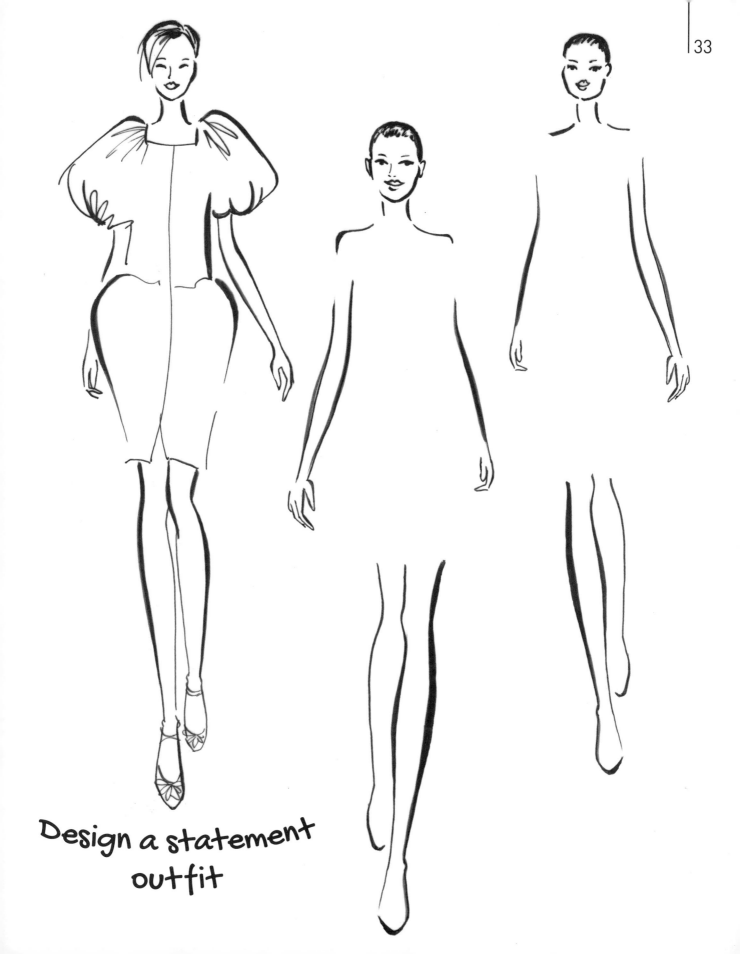

Design a statement
outfit

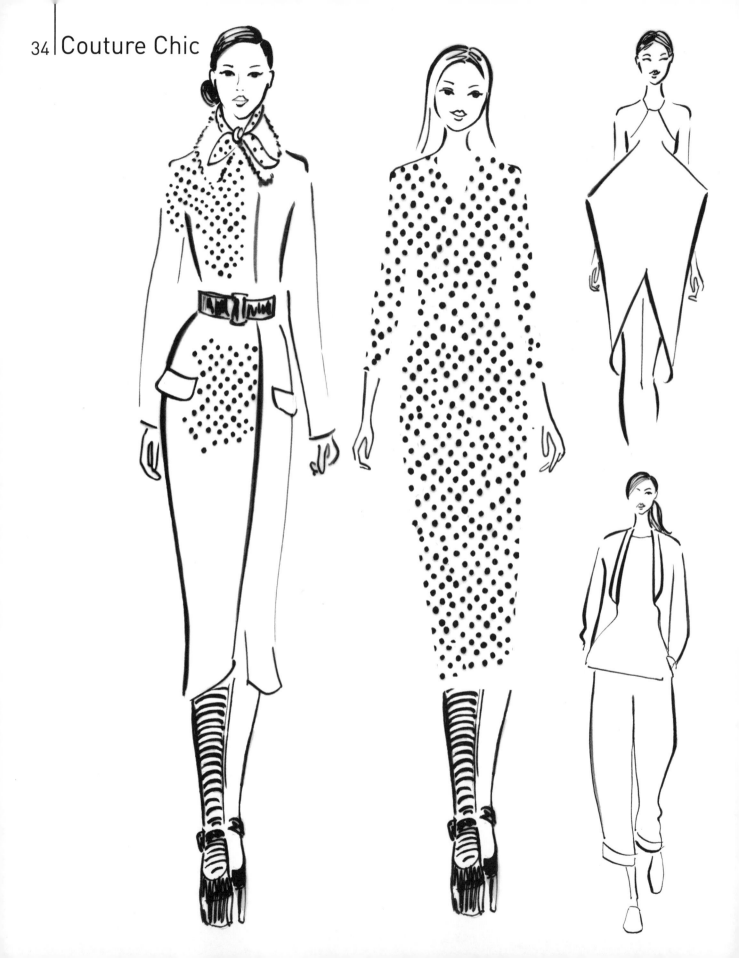

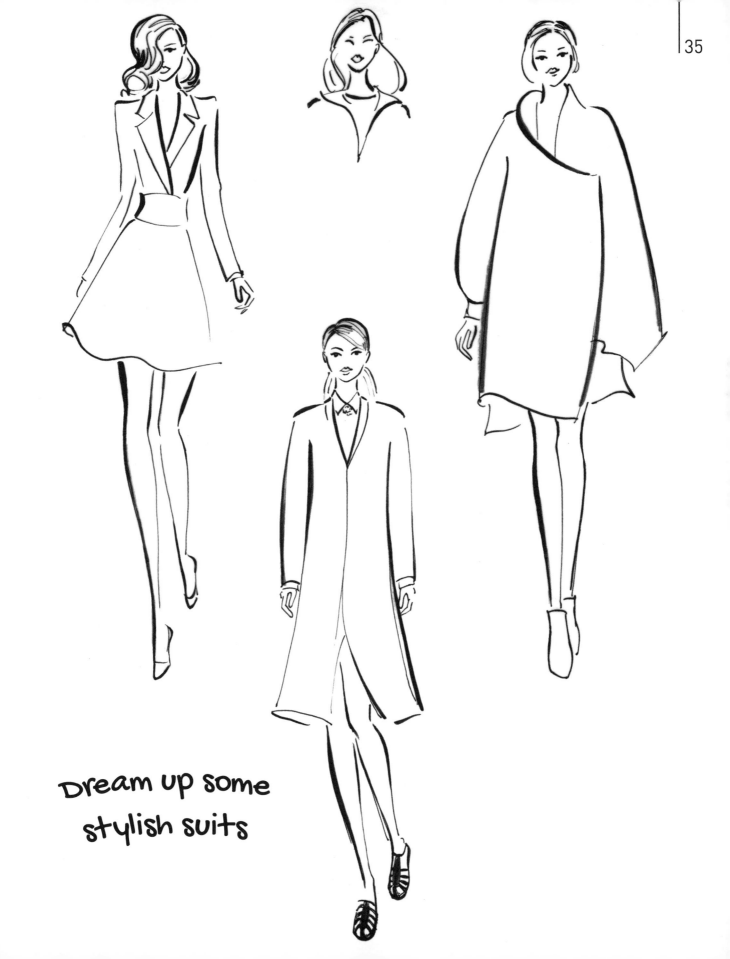

Dream up some
stylish suits

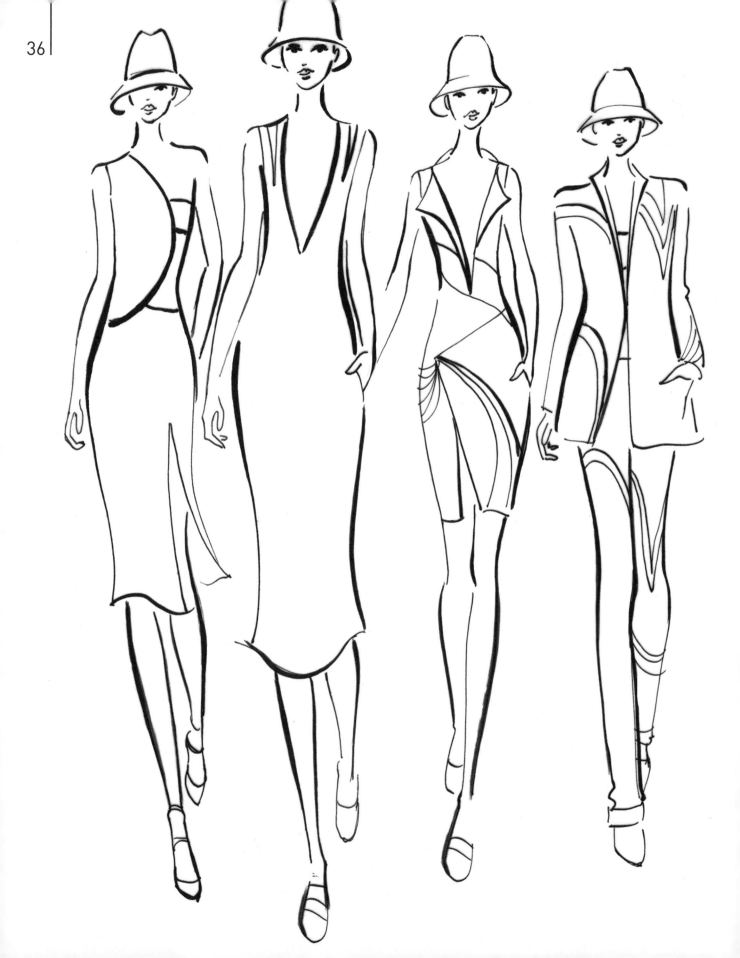

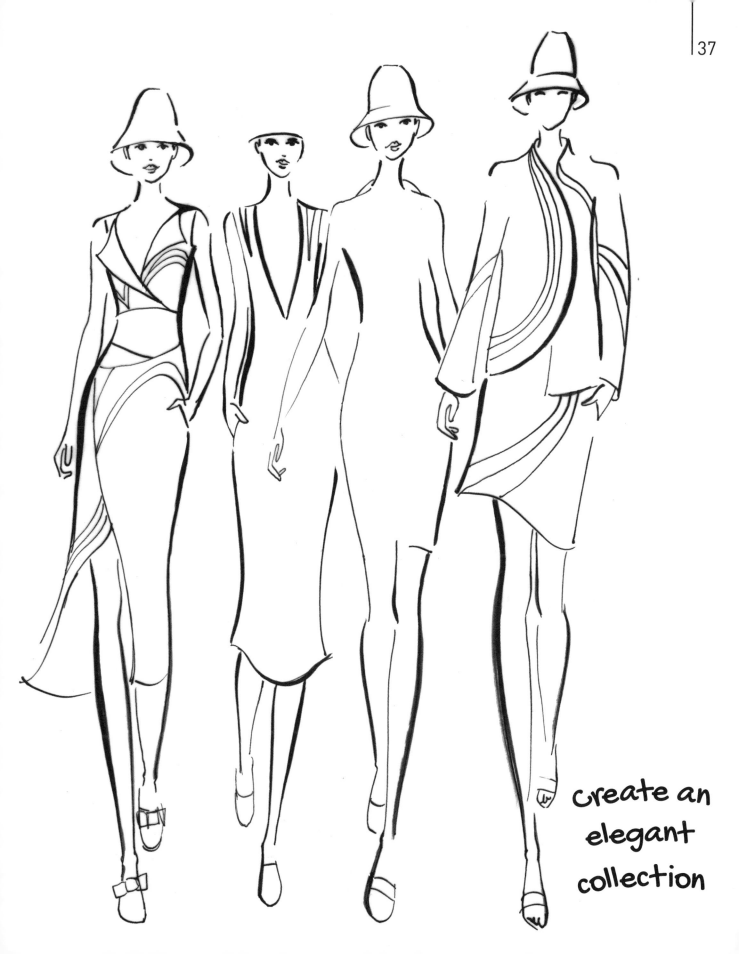

create an
elegant
collection

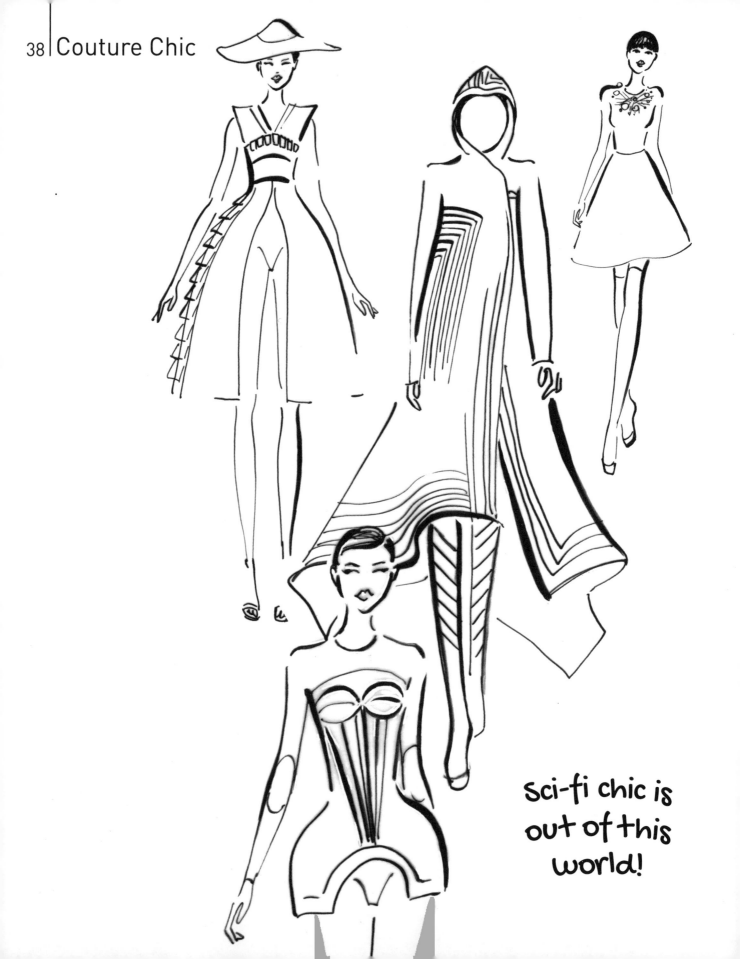

Sci-fi chic is out of this world!

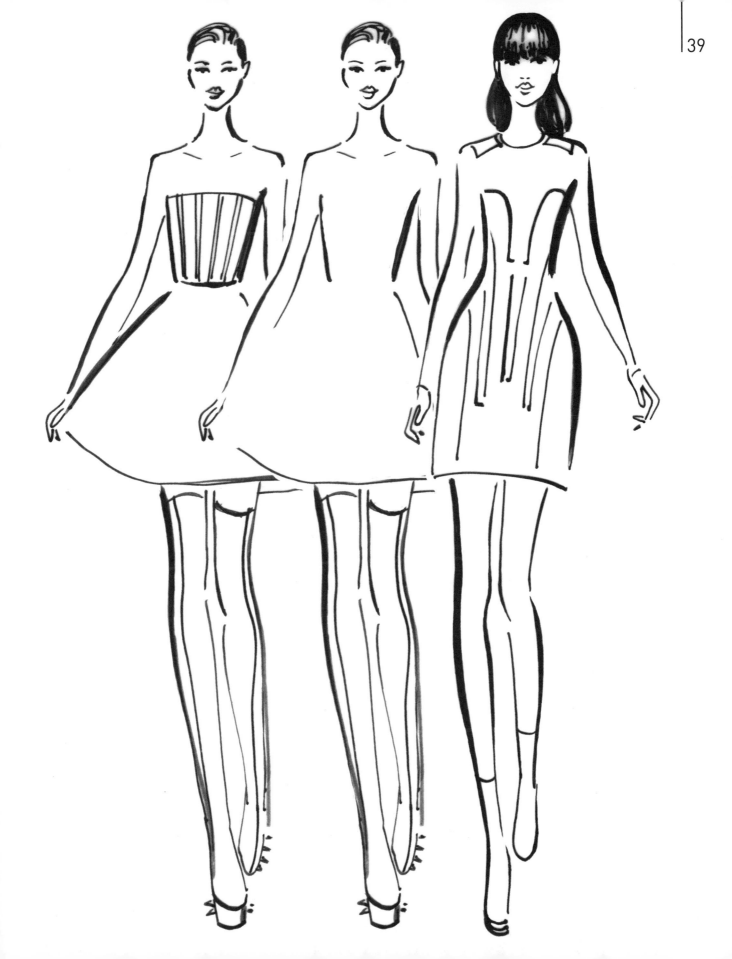

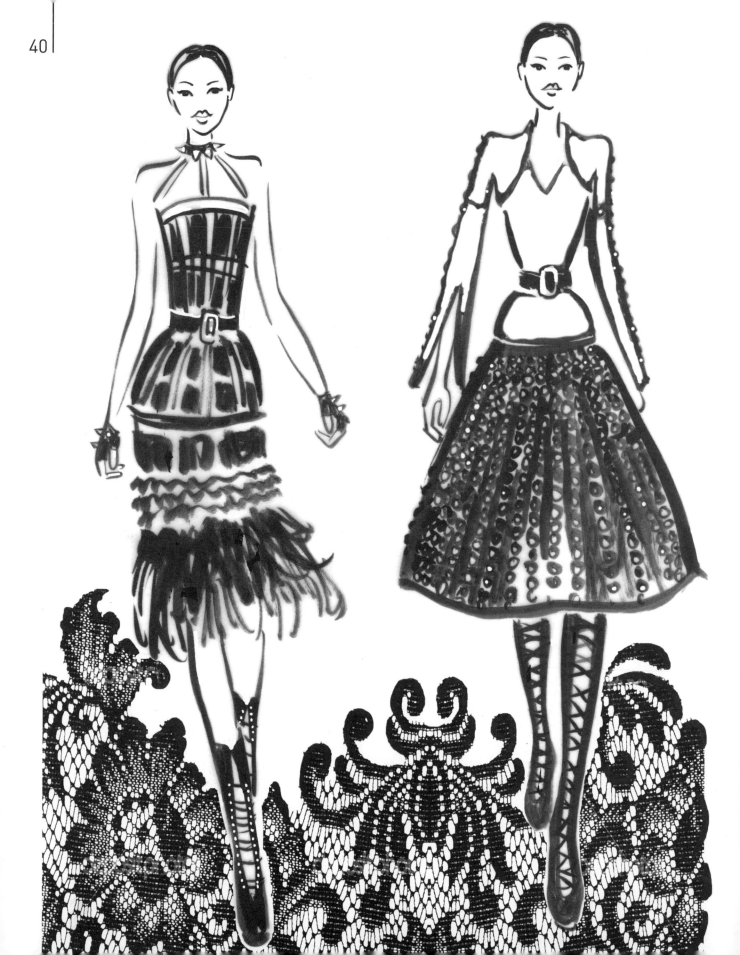

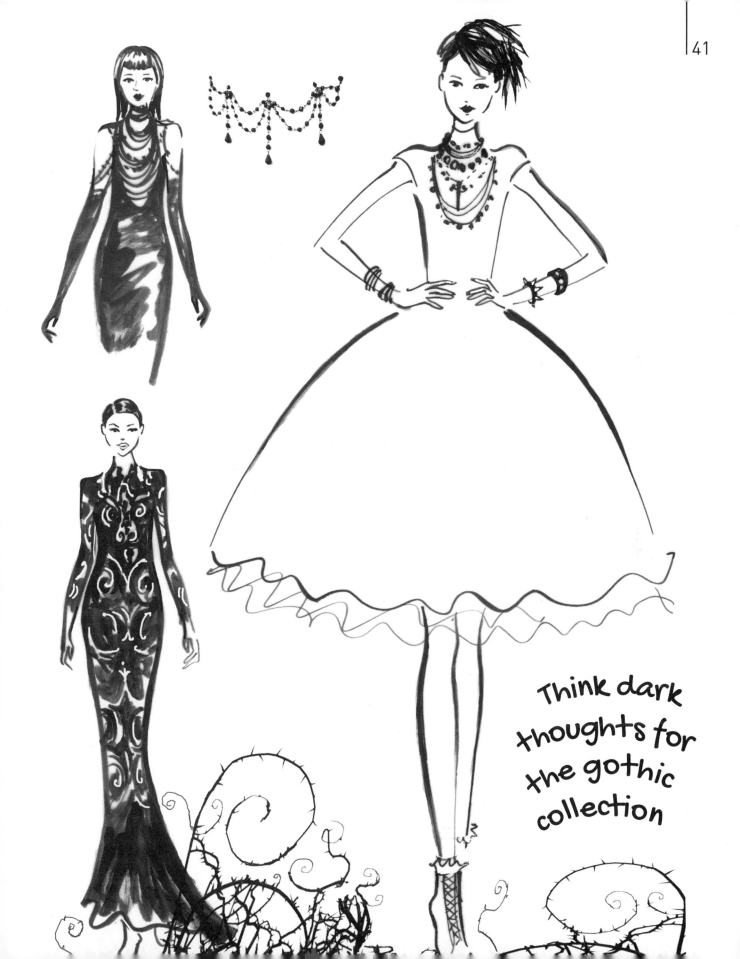

Think dark thoughts for the gothic collection

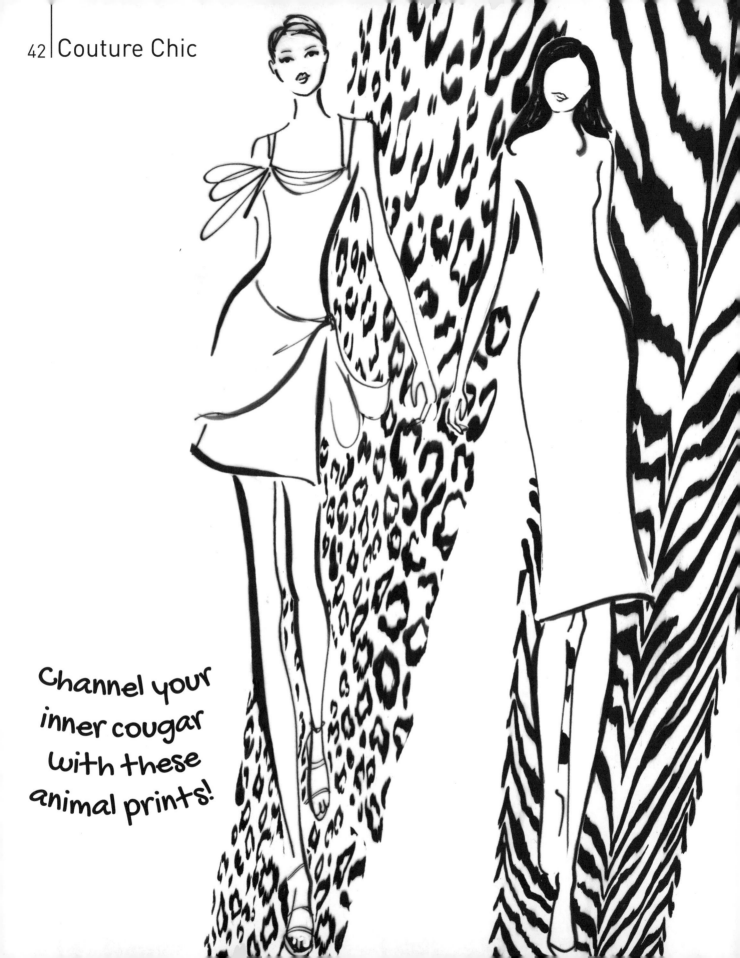

Channel your inner cougar with these animal prints!

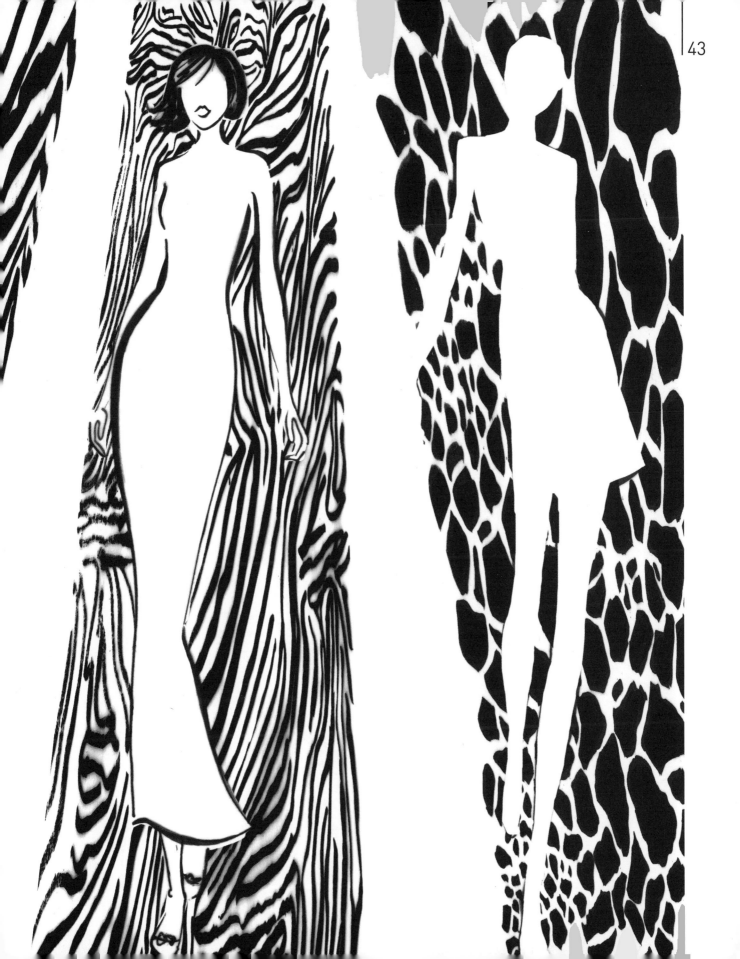

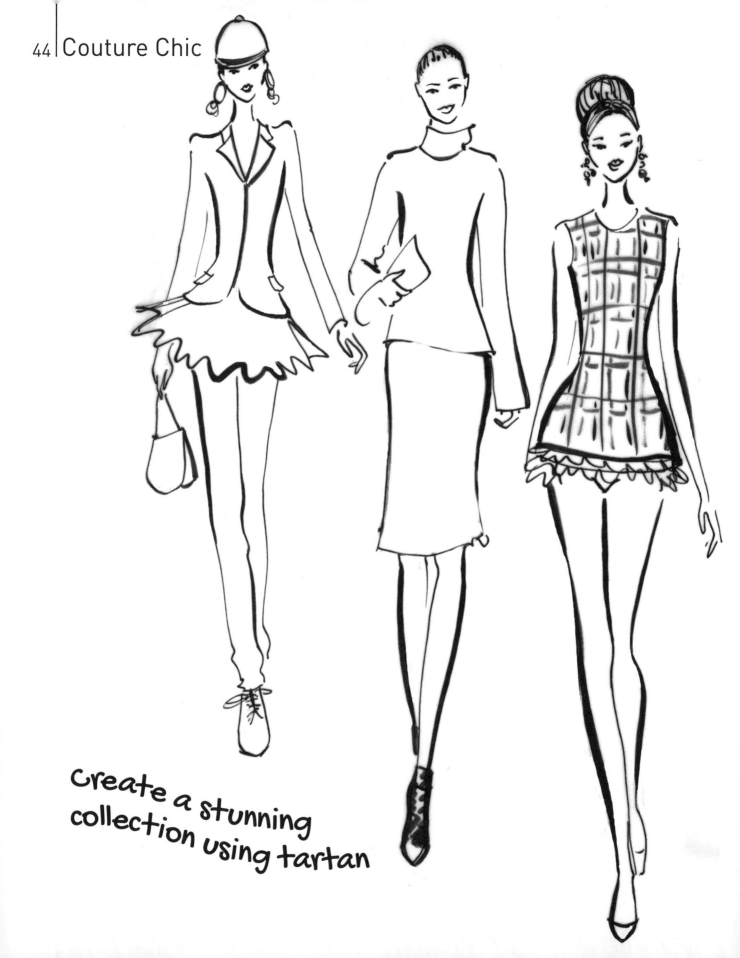

Create a stunning
collection using tartan

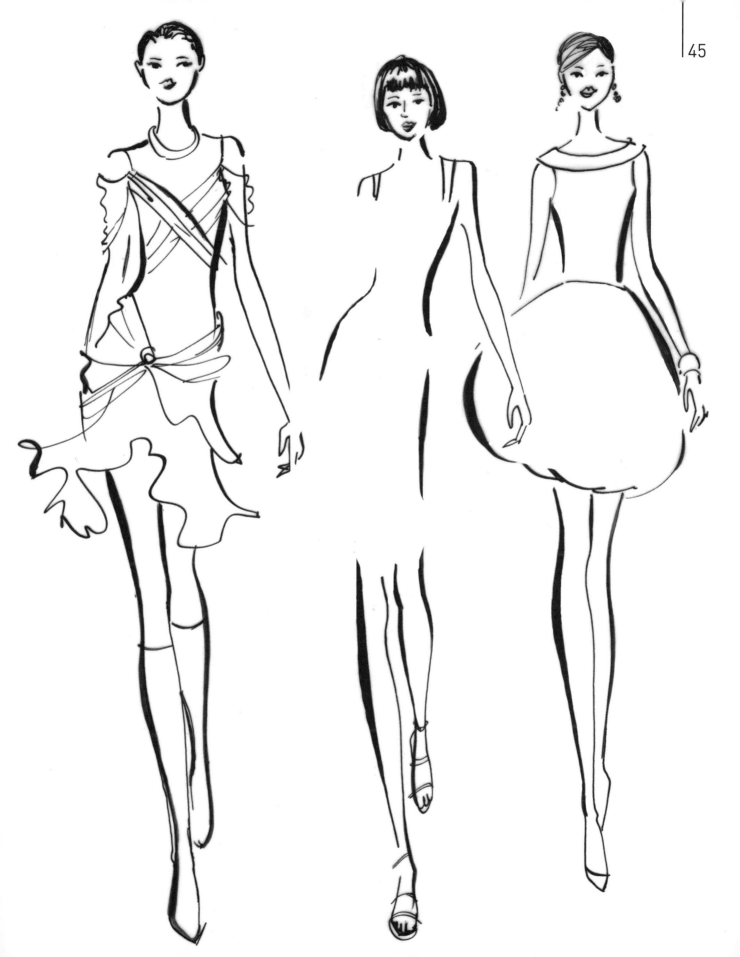

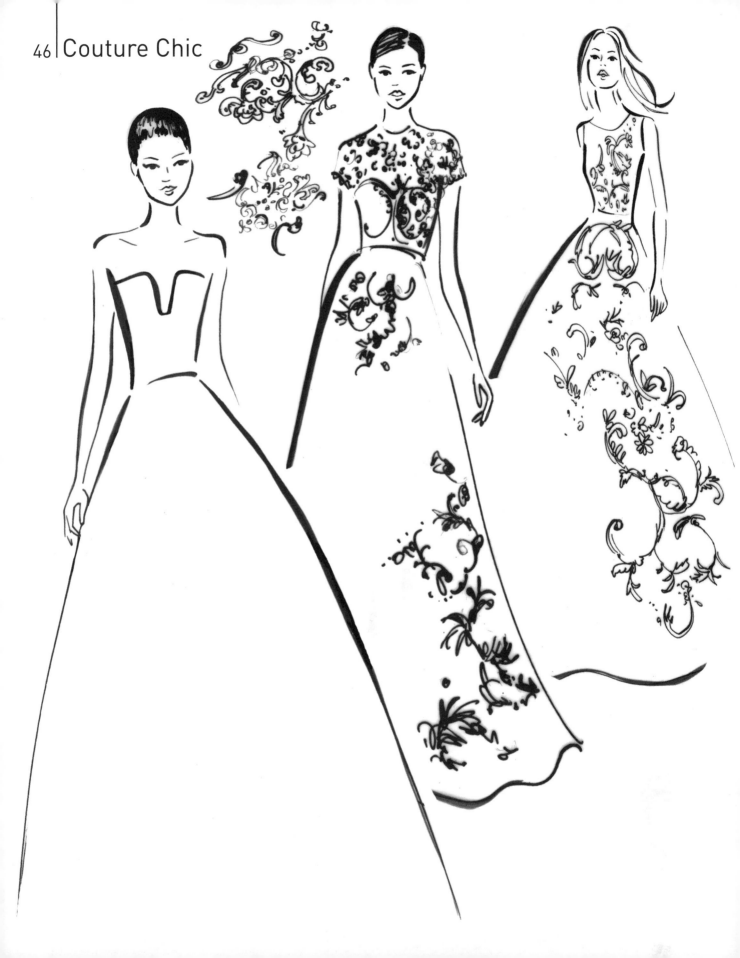

Design your
own evening dress

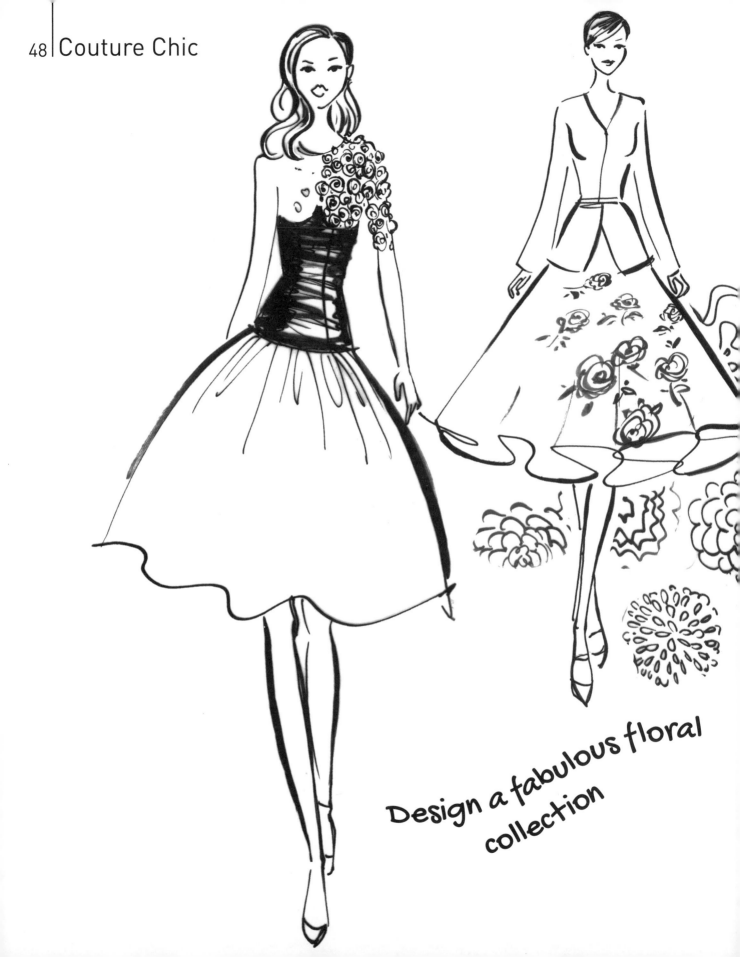

Design a fabulous floral collection

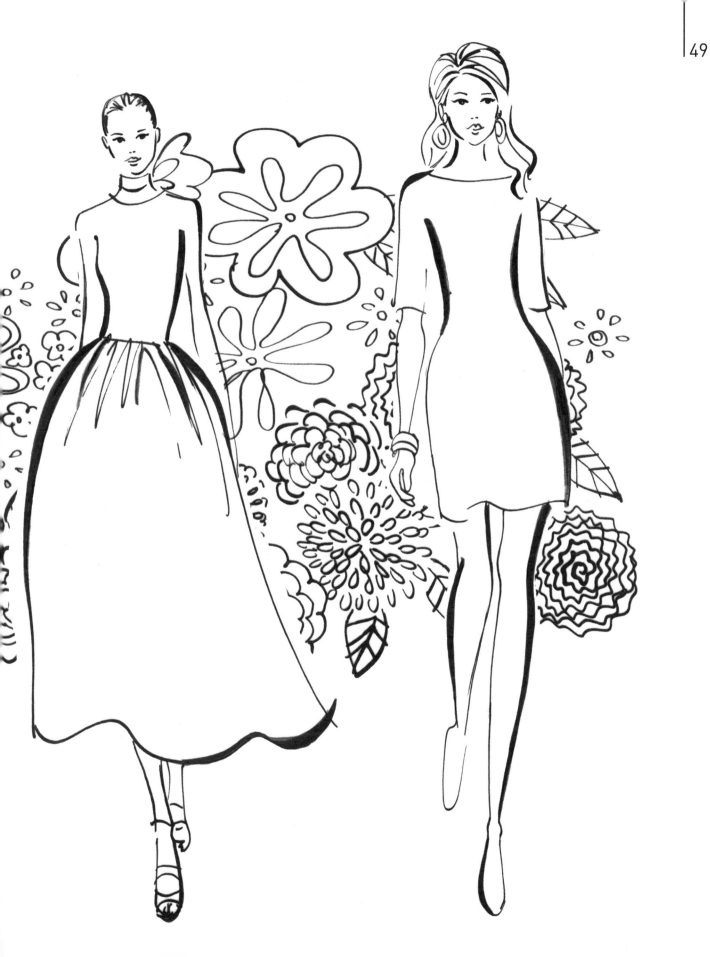

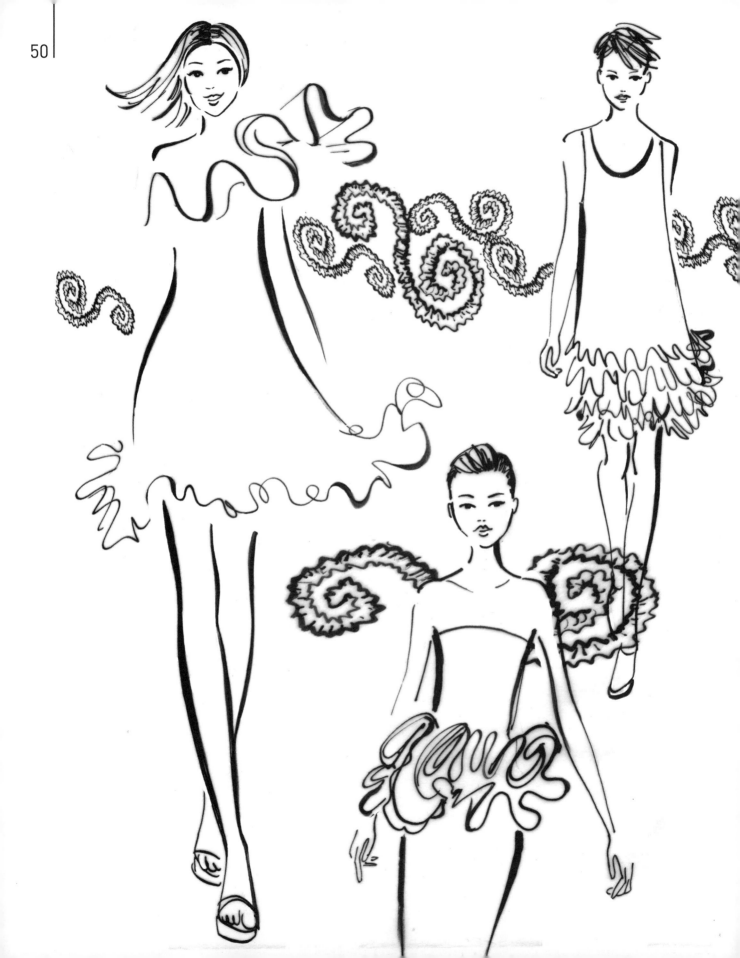

Dresses with frills require some serious doodling!

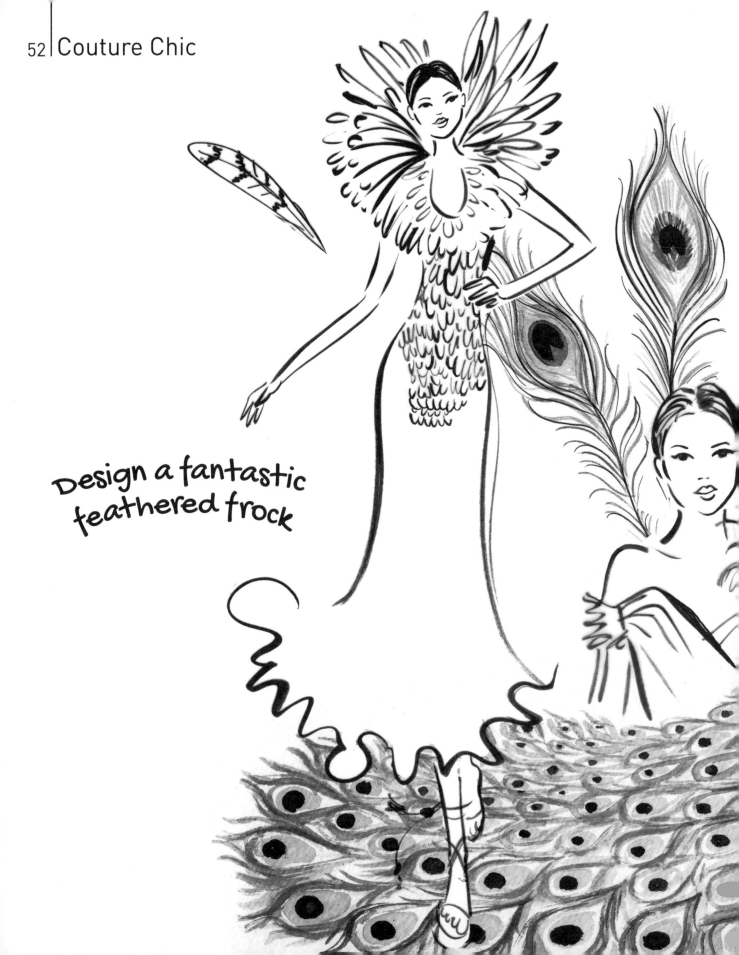

Design a fantastic
feathered frock

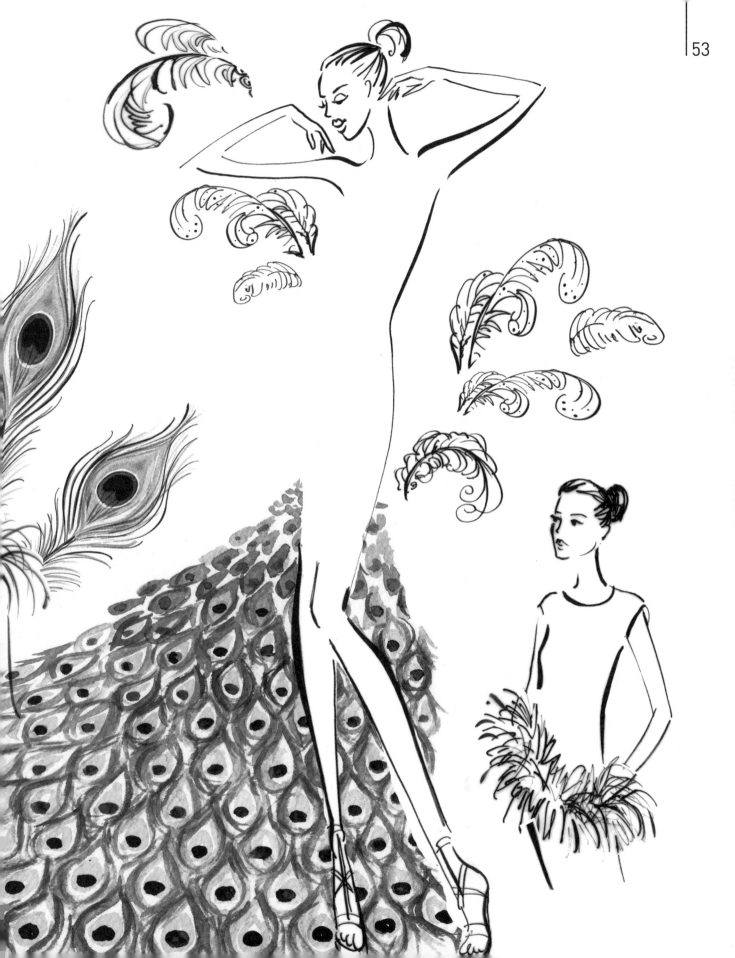

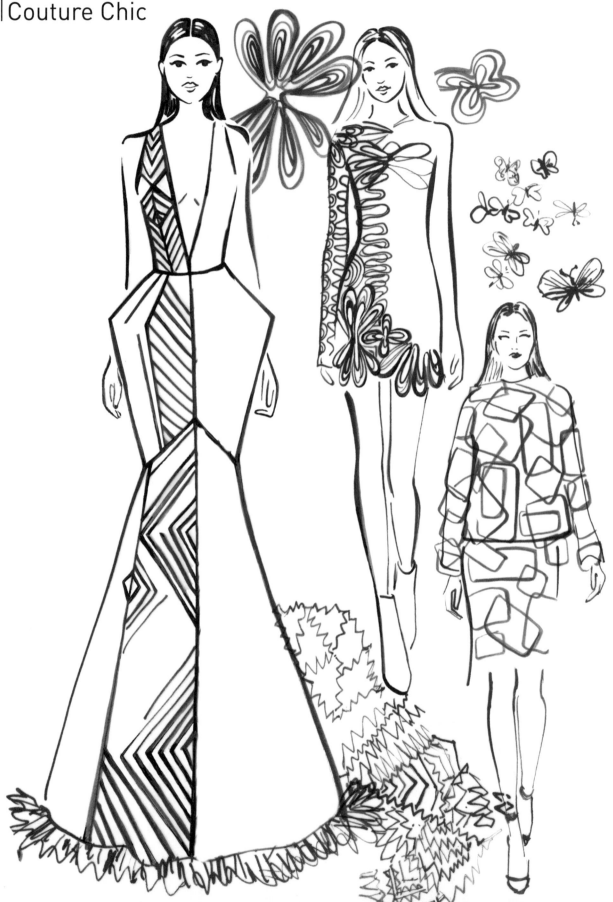

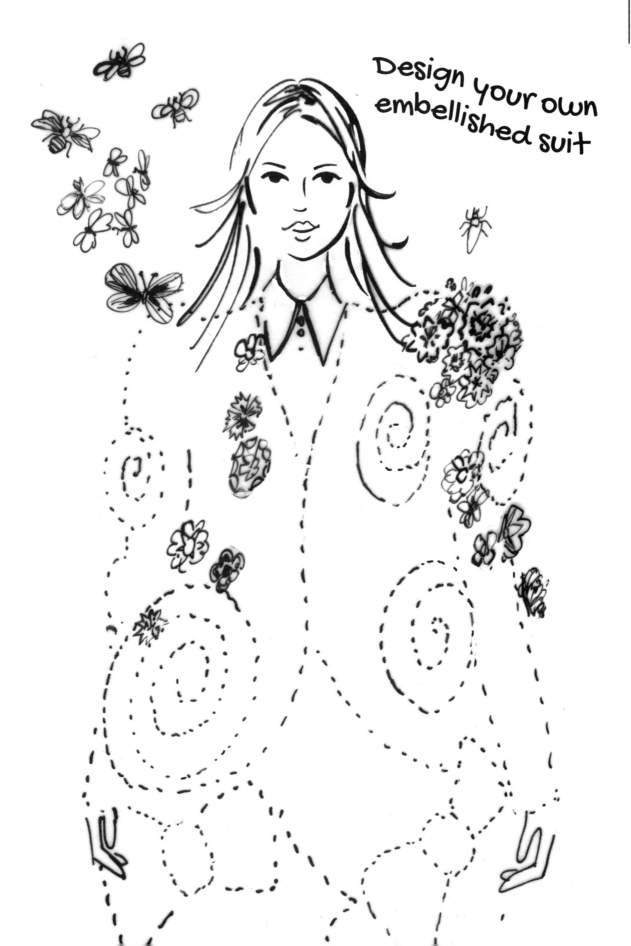

Design your own embellished suit

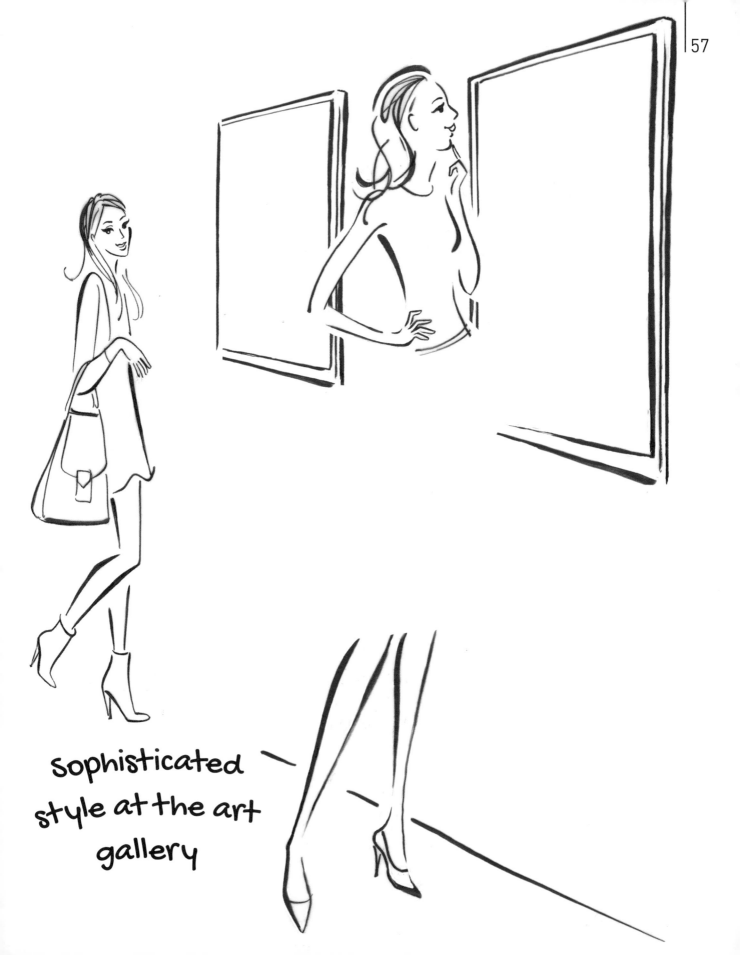

sophisticated style at the art gallery

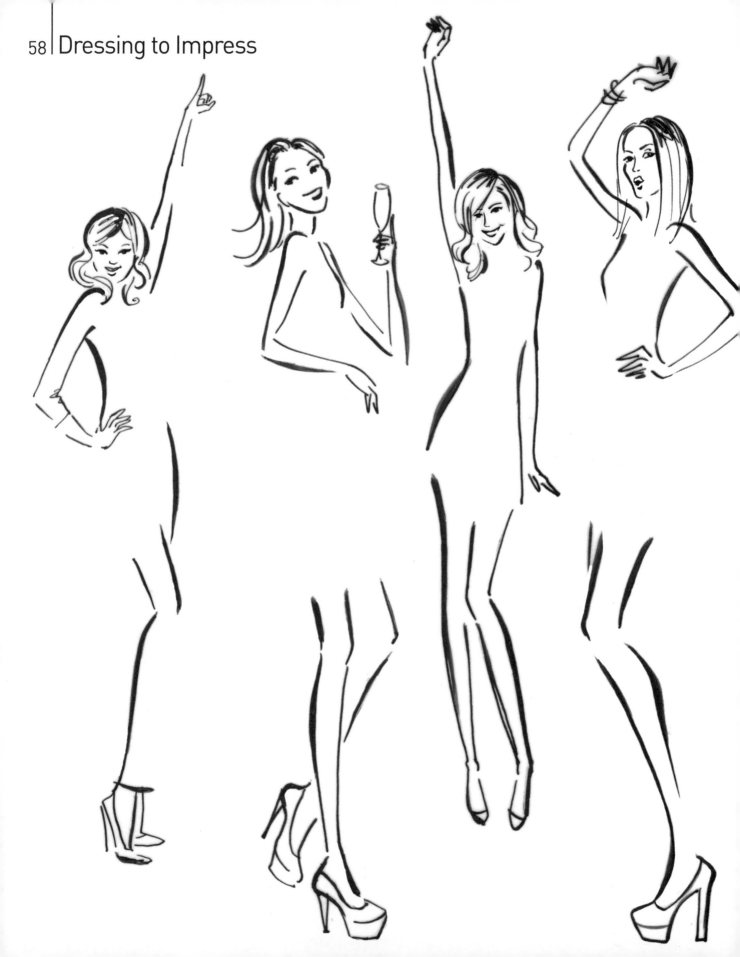

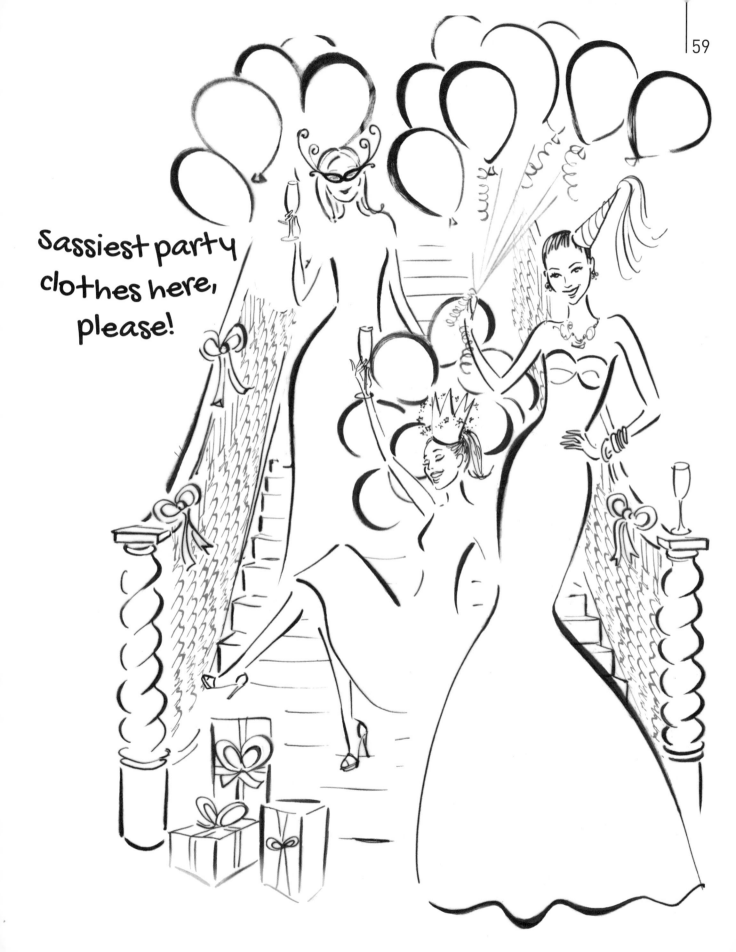

Sassiest party clothes here, please!

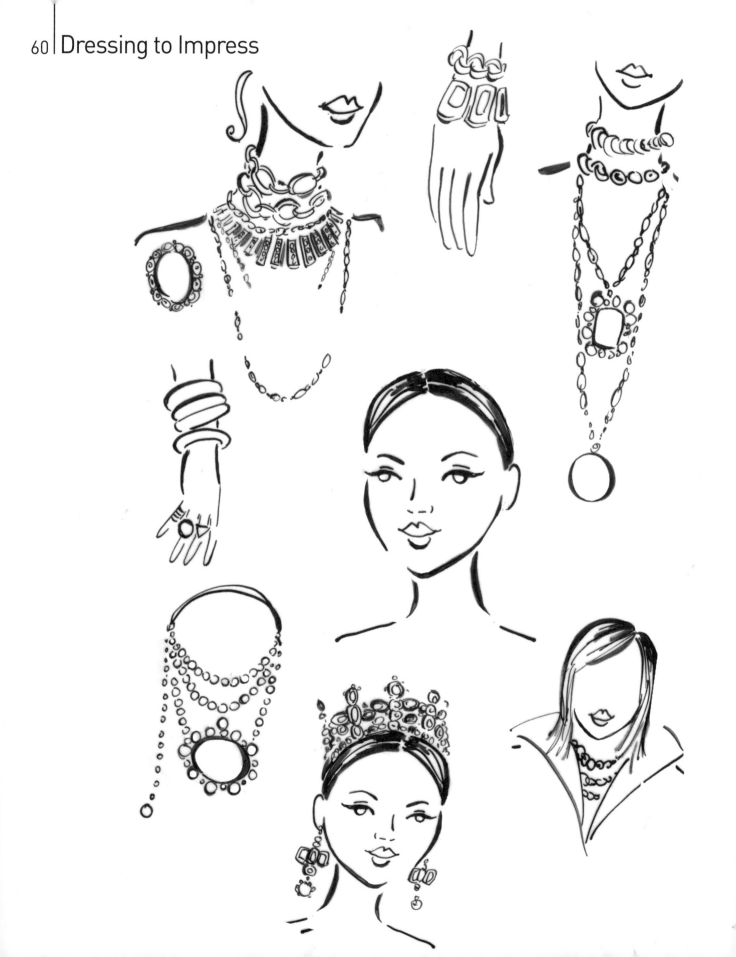

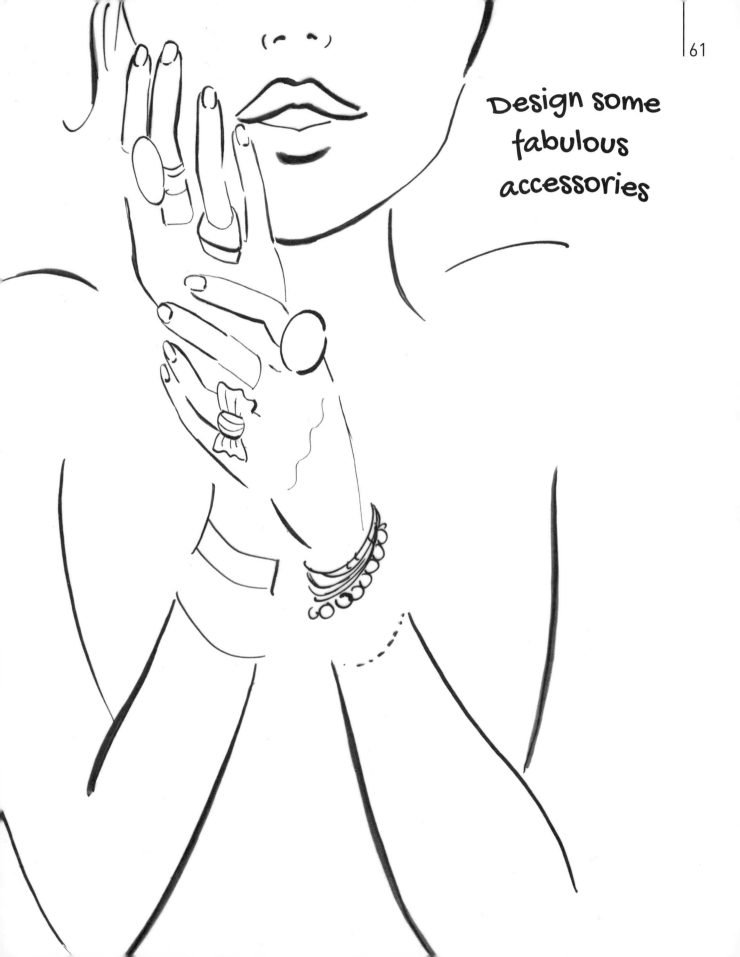

Design some fabulous accessories

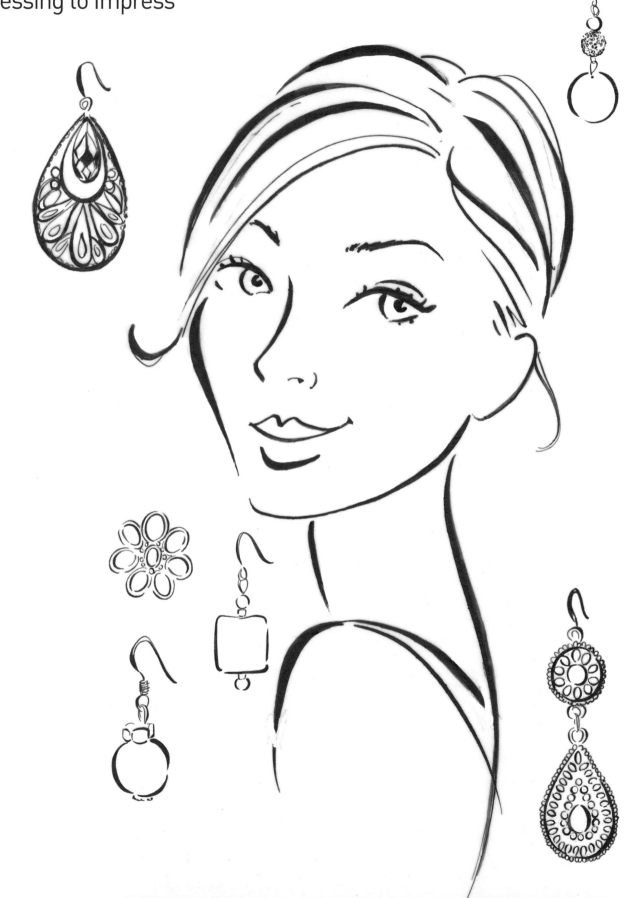

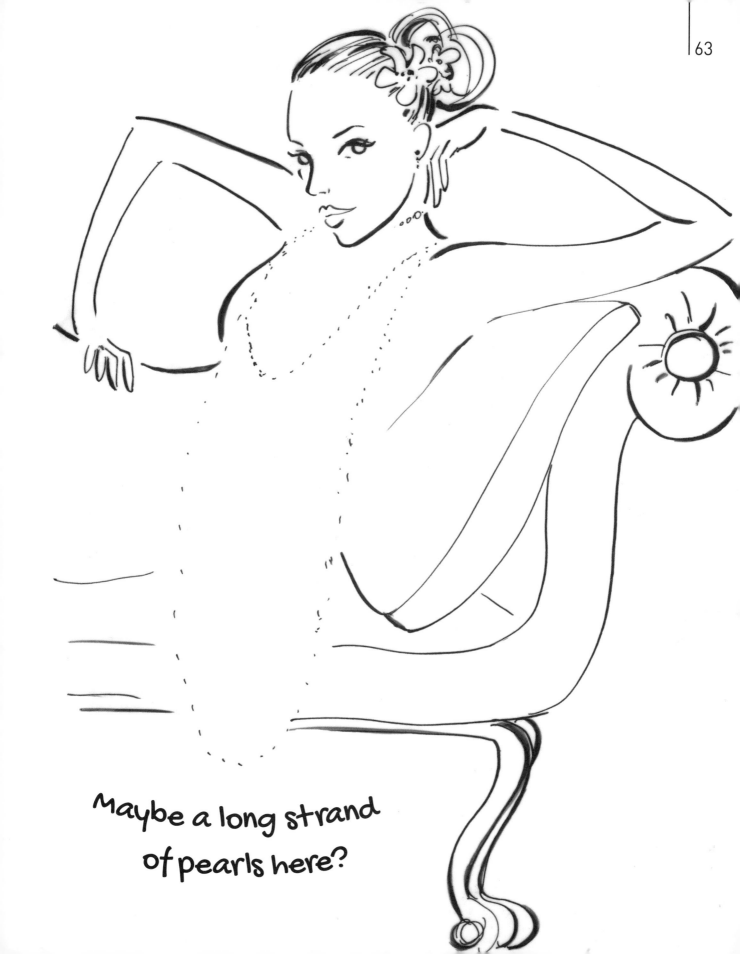

Maybe a long strand
of pearls here?

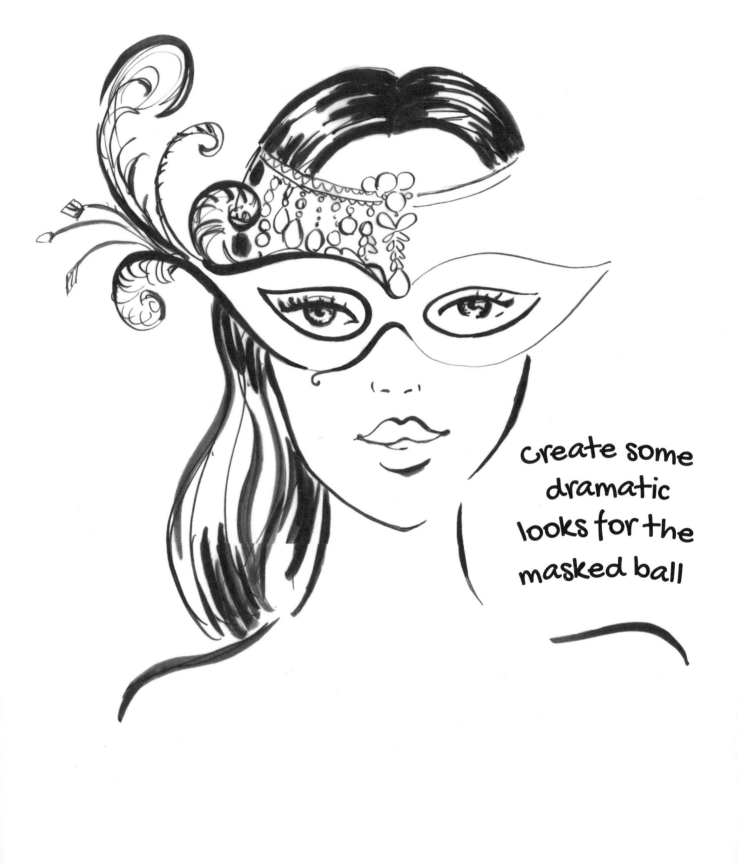

create some
dramatic
looks for the
masked ball

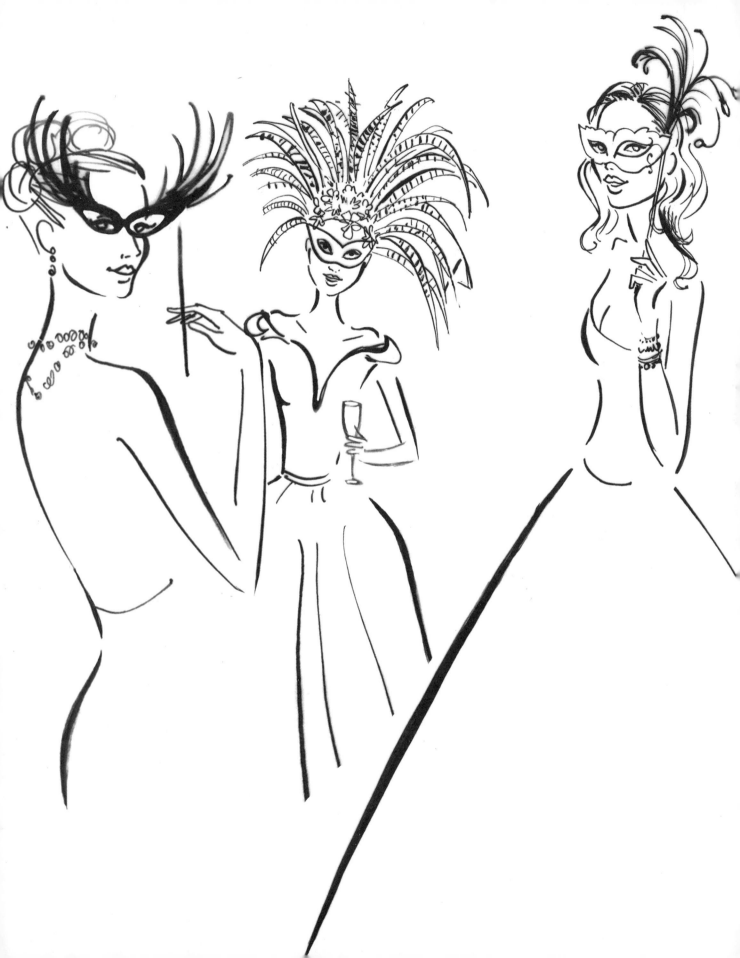

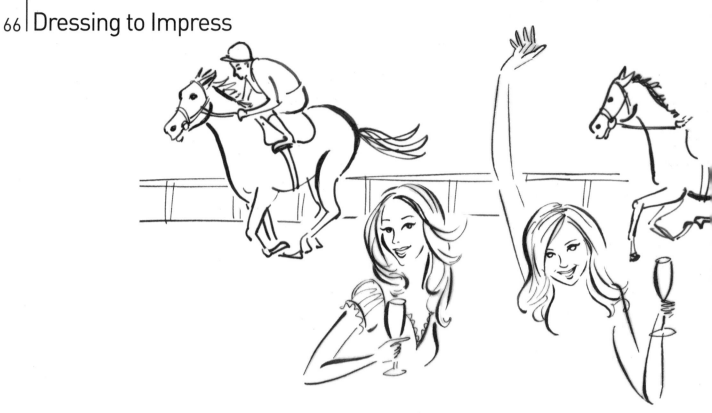

Design some jaunty
items for ladies' day
at the races...

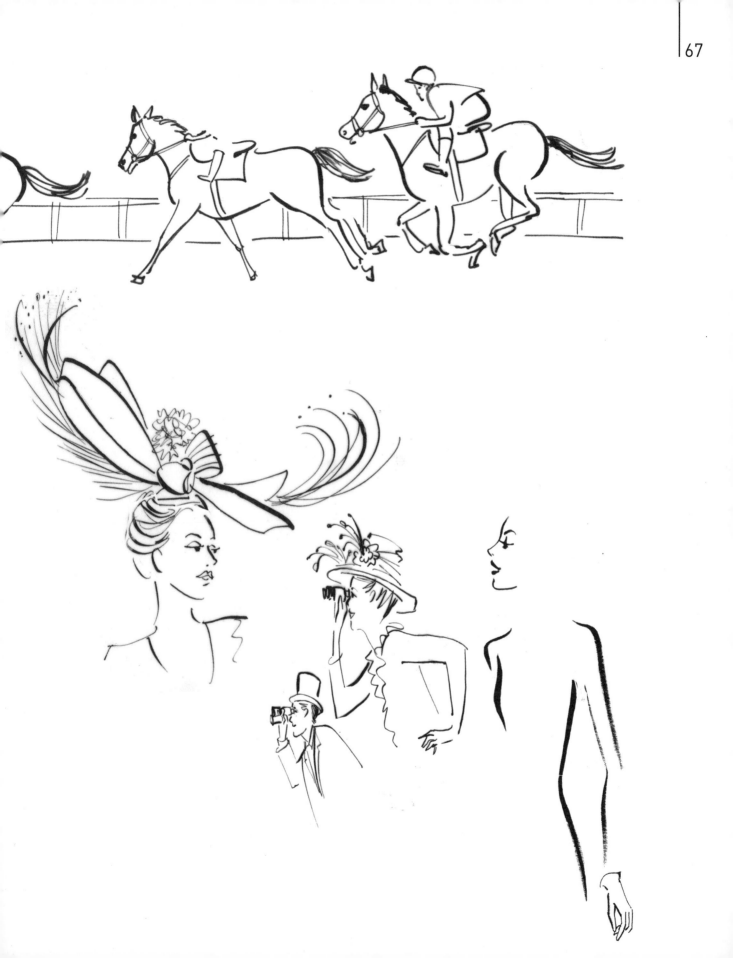

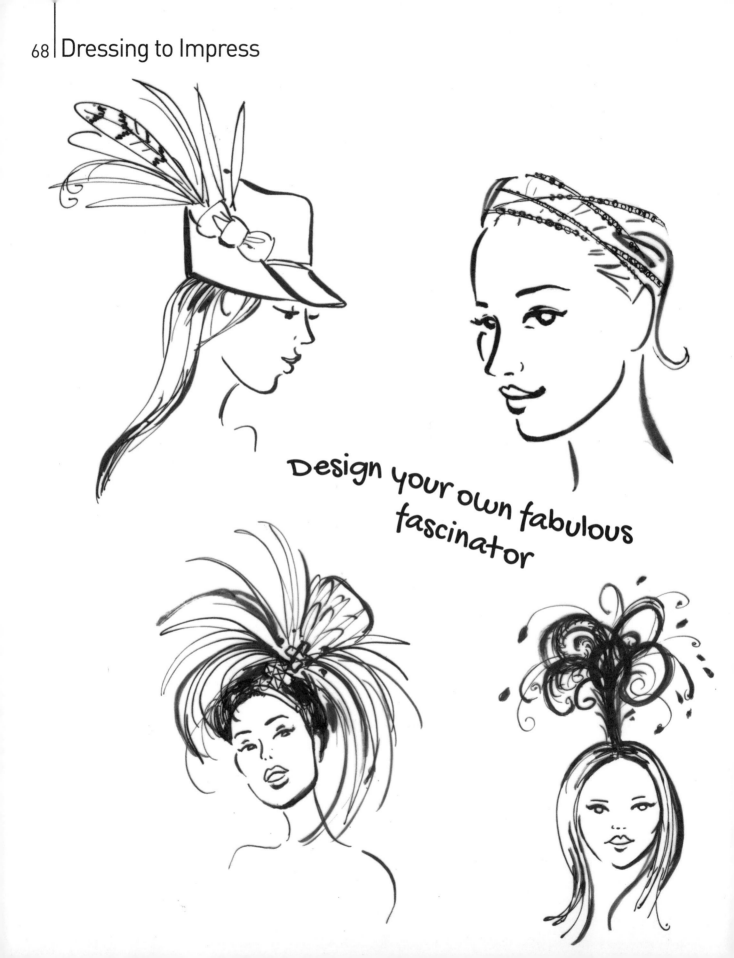

Design your own fabulous fascinator

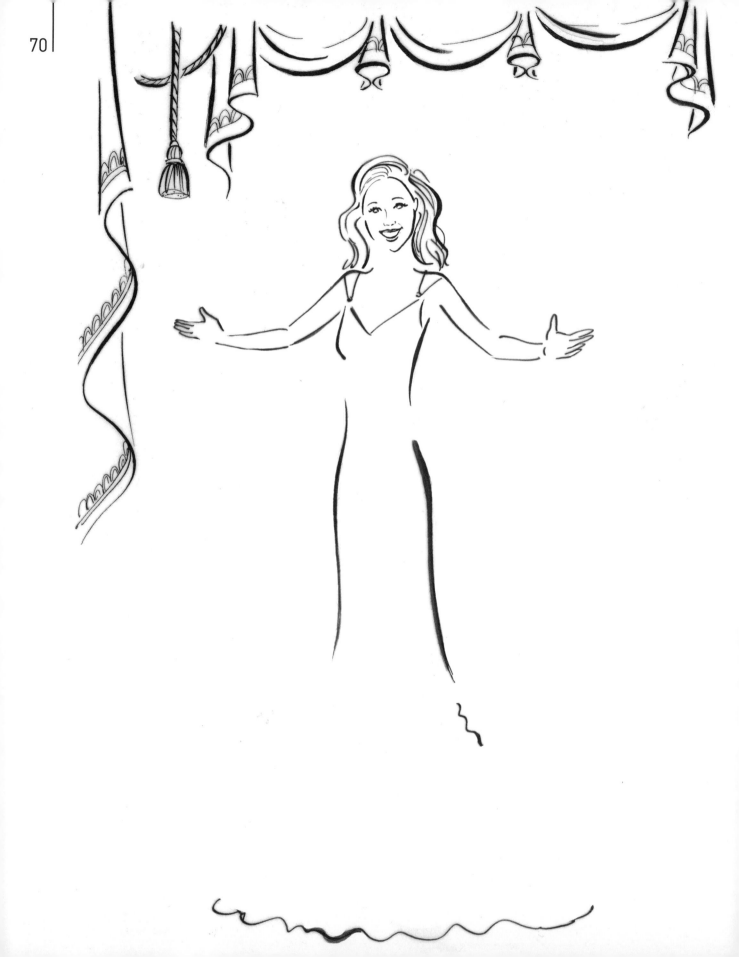

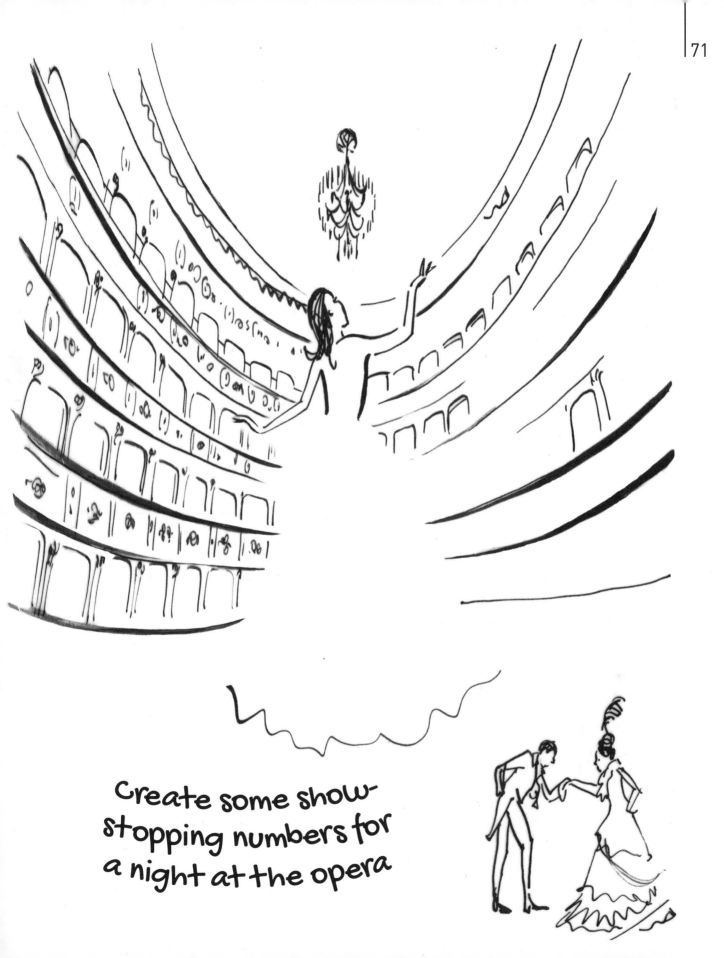

Create some show-stopping numbers for a night at the opera

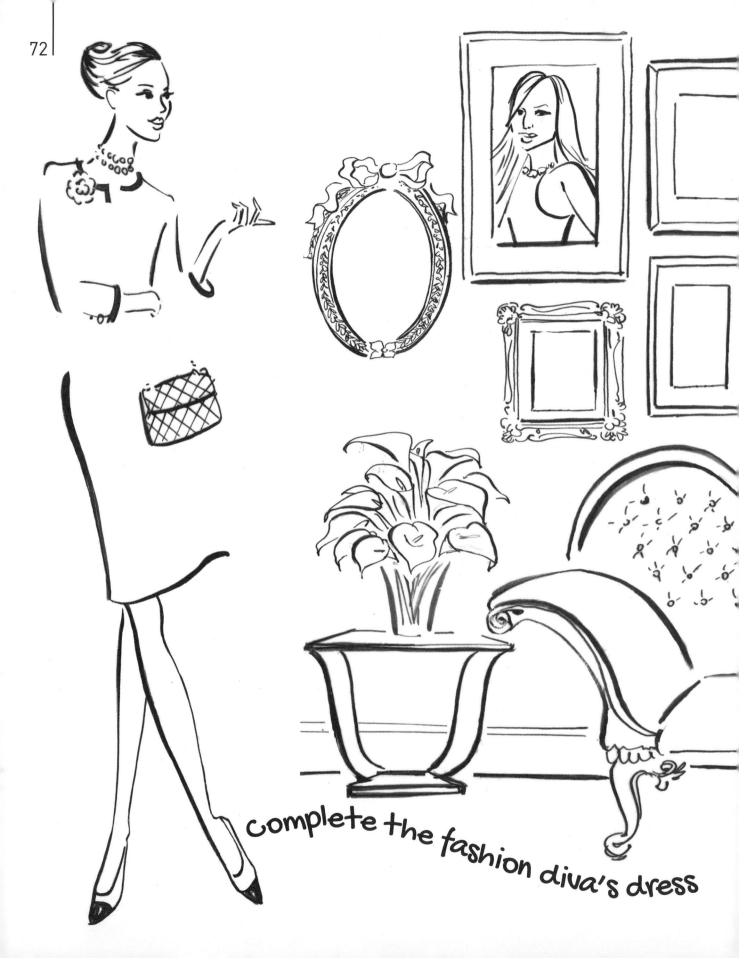

complete the fashion diva's dress

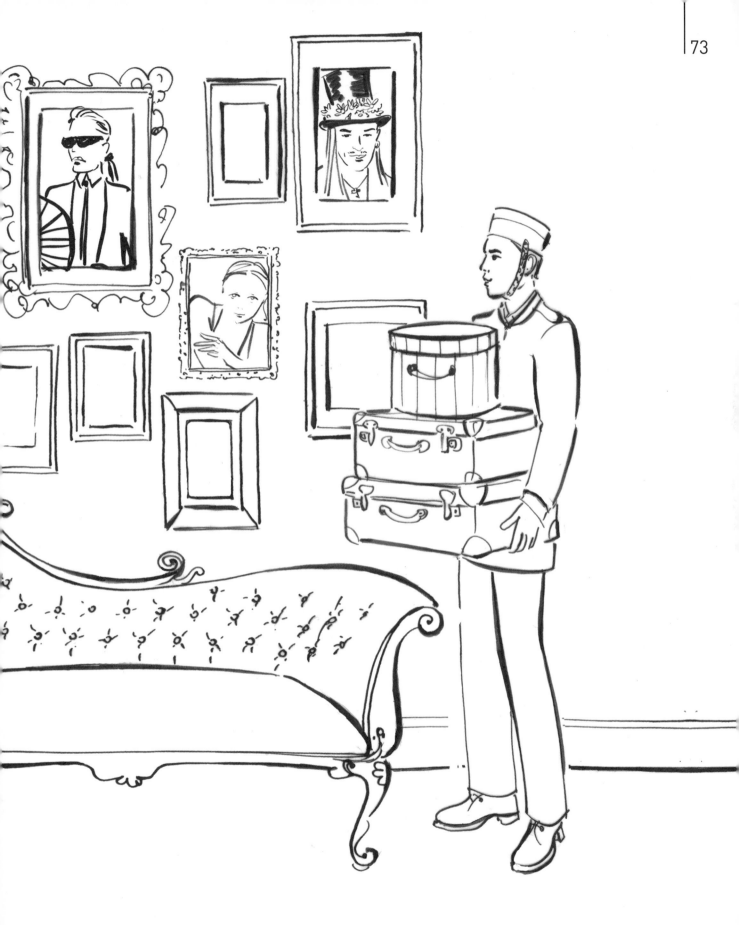

Doodle some designer statement looks

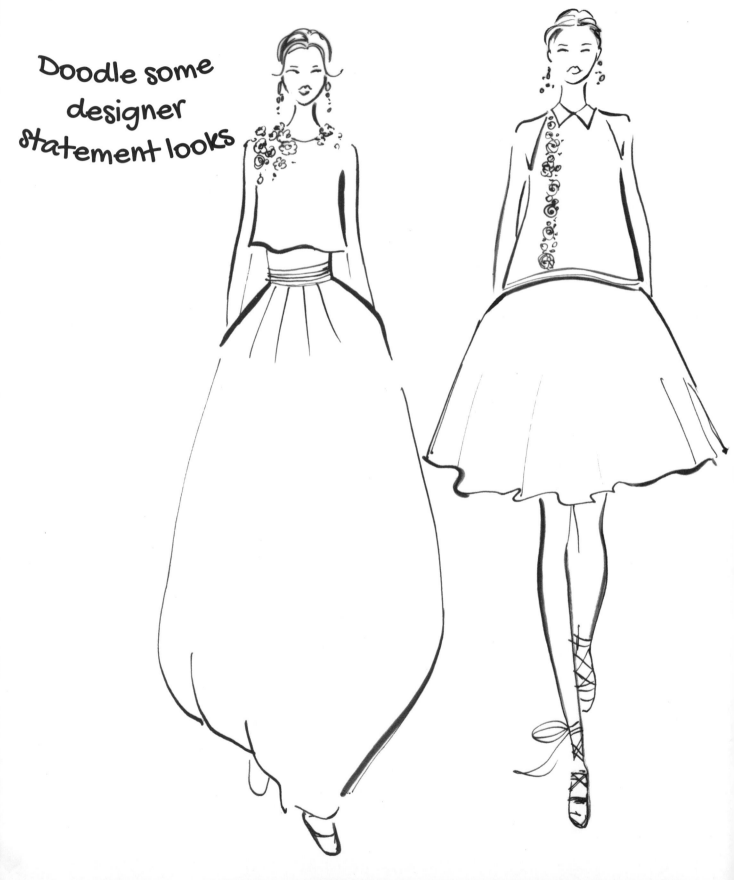

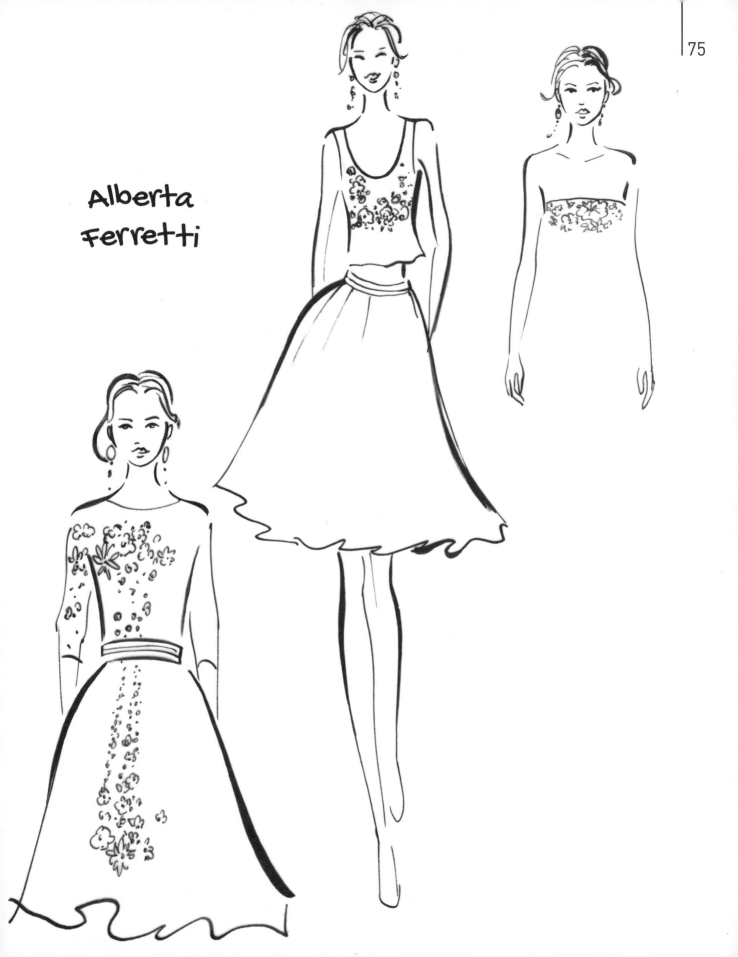

Alberta
Ferretti

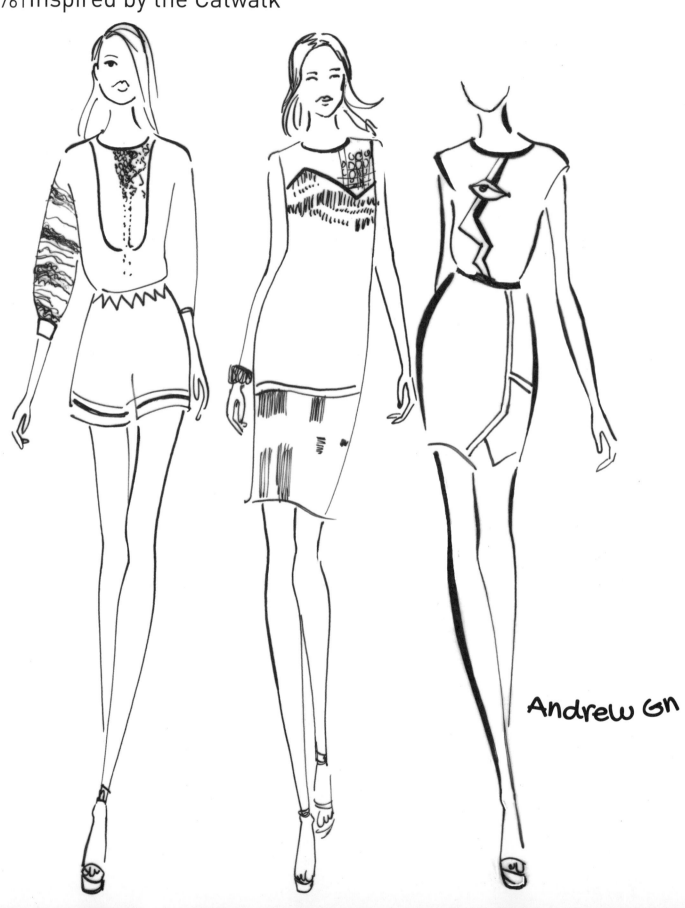

Andrew Gn

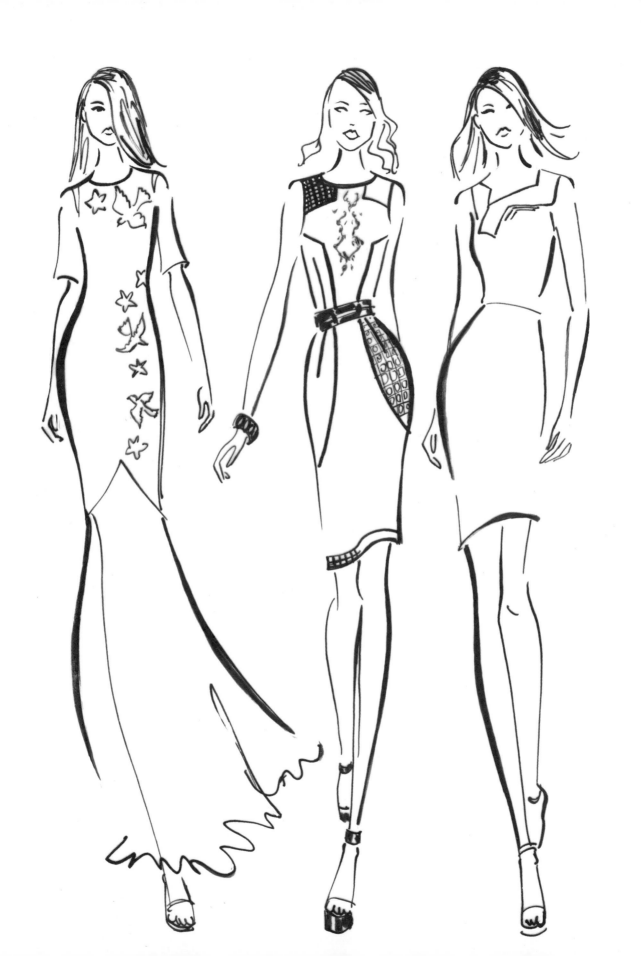

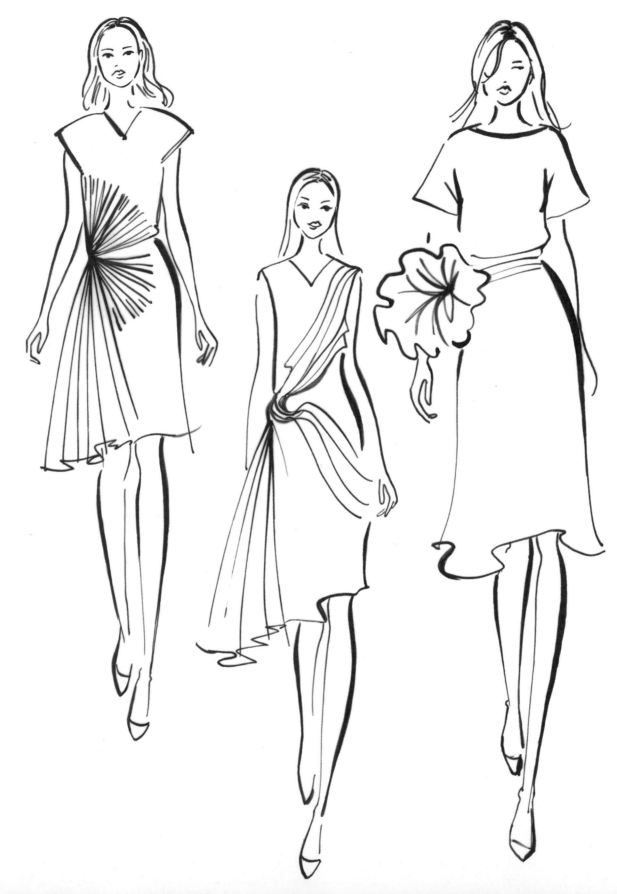

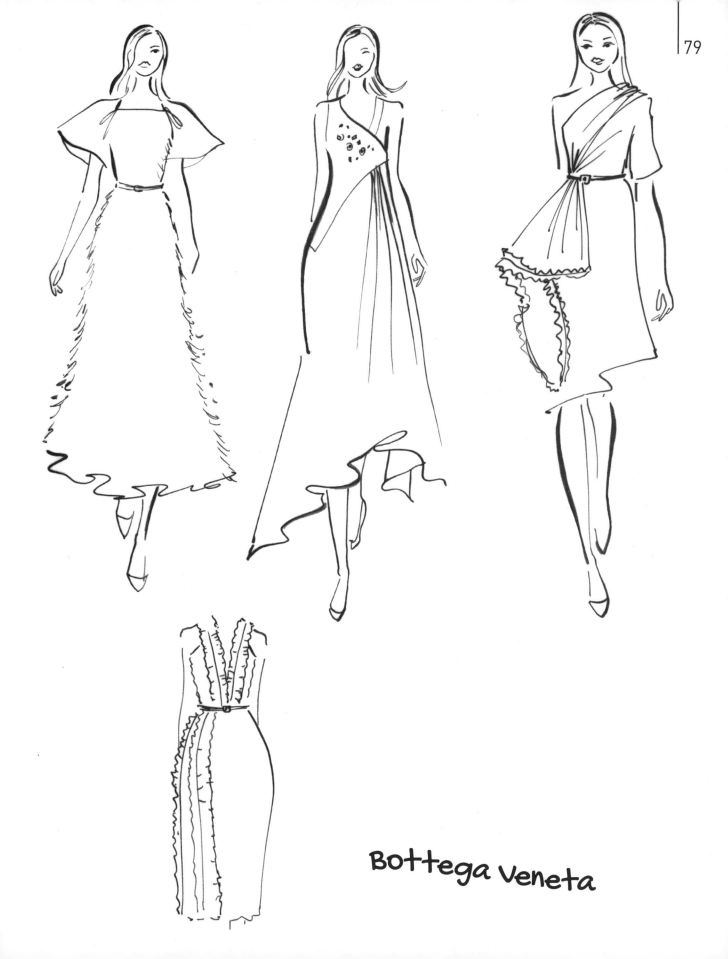

Bottega Veneta

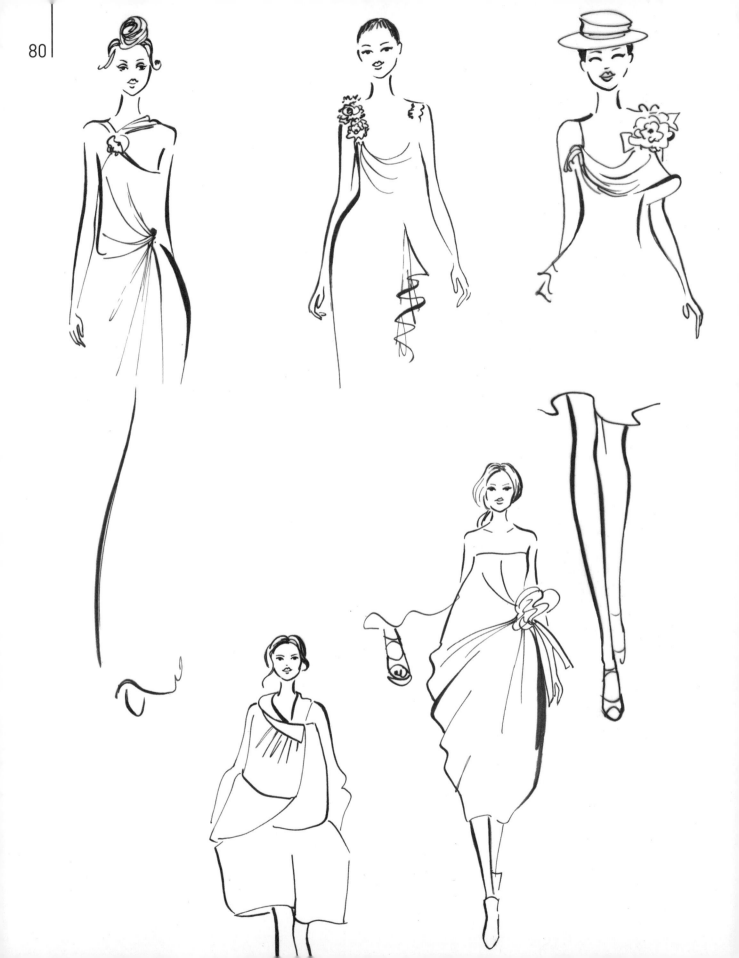

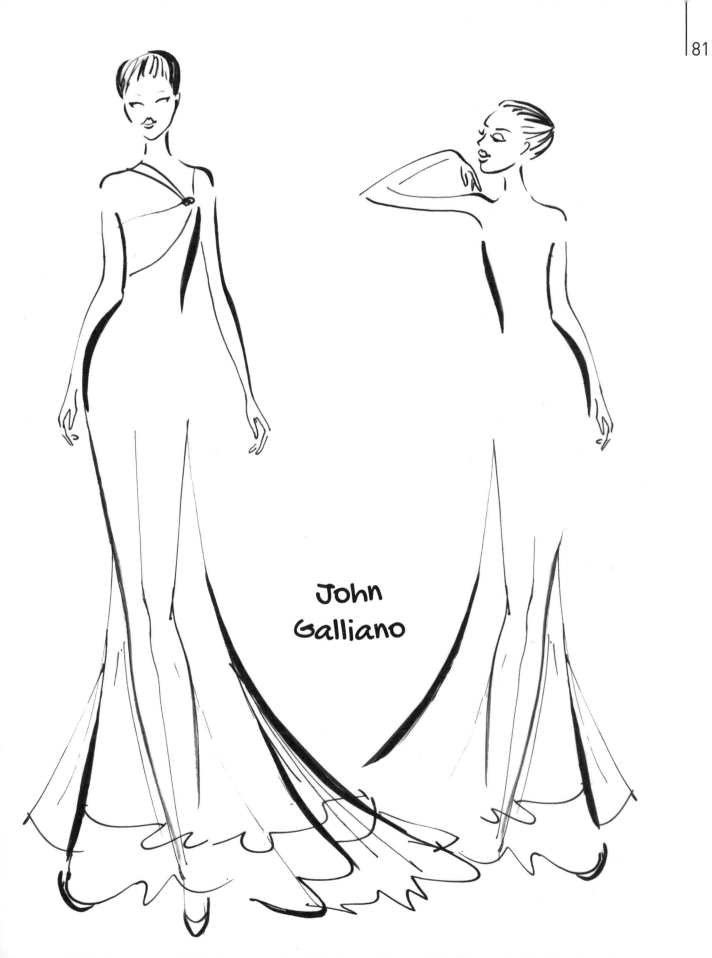

John
Galliano

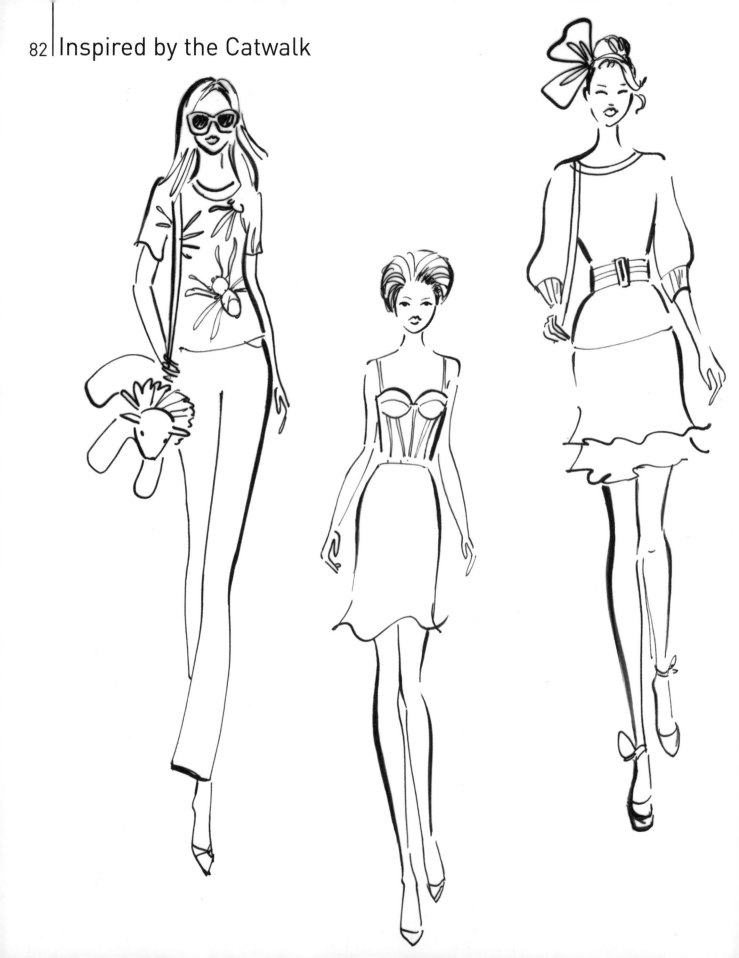

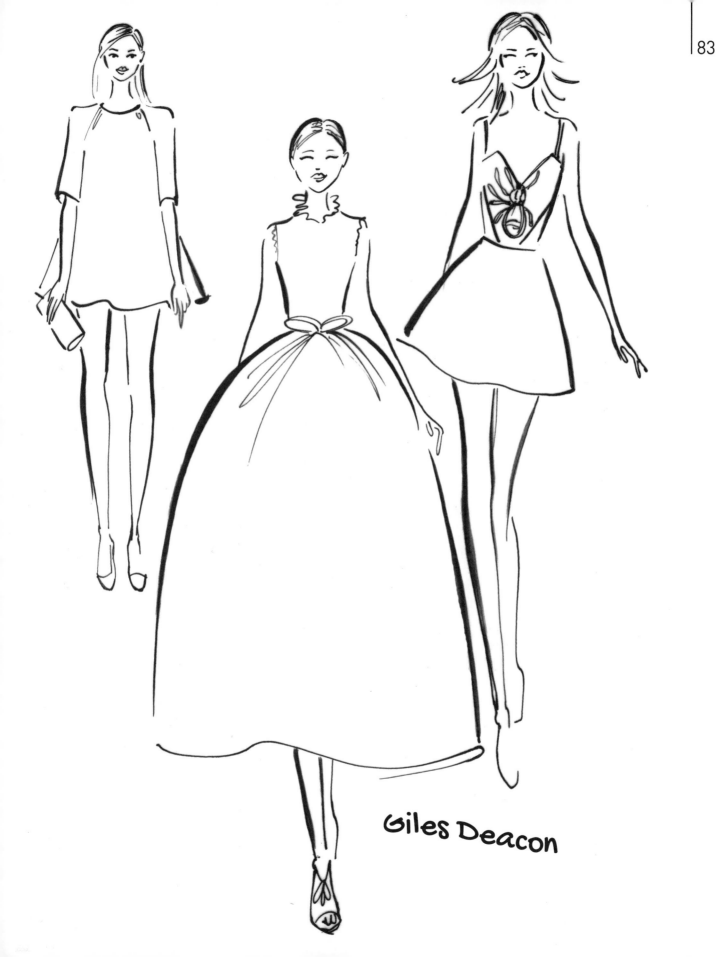

Giles Deacon

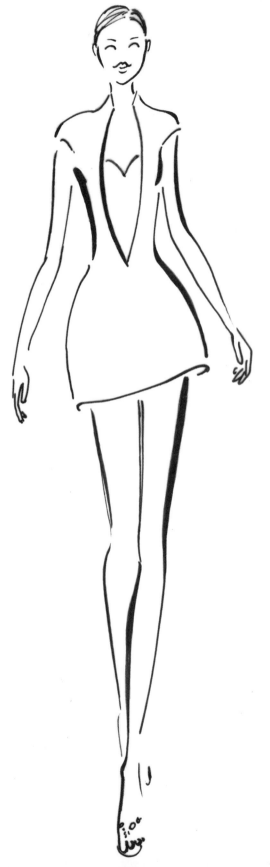
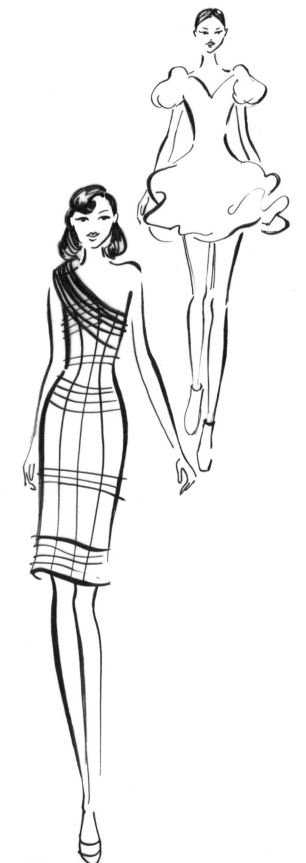

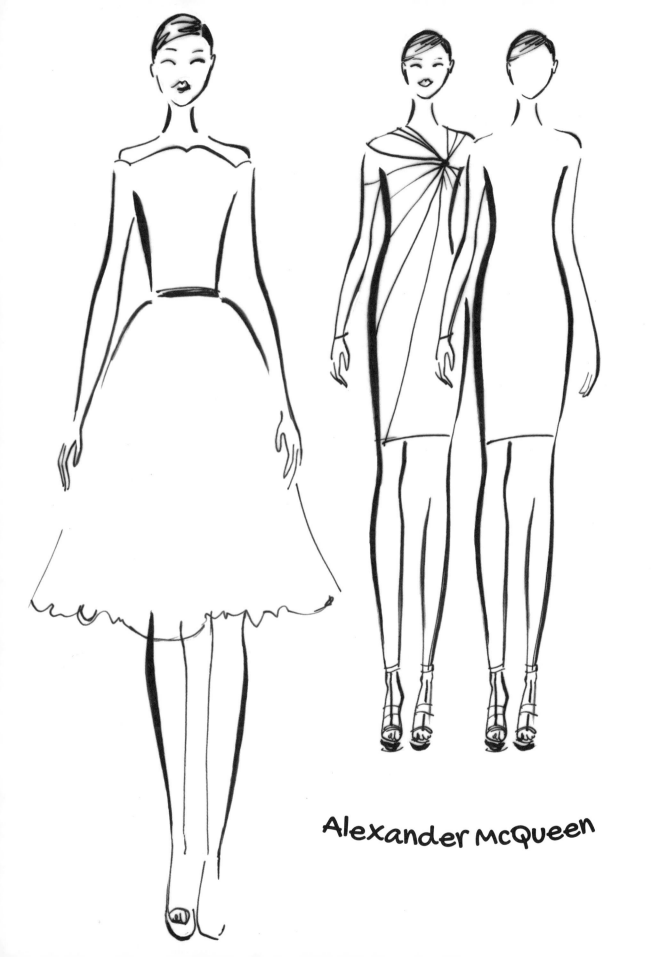

Alexander McQueen

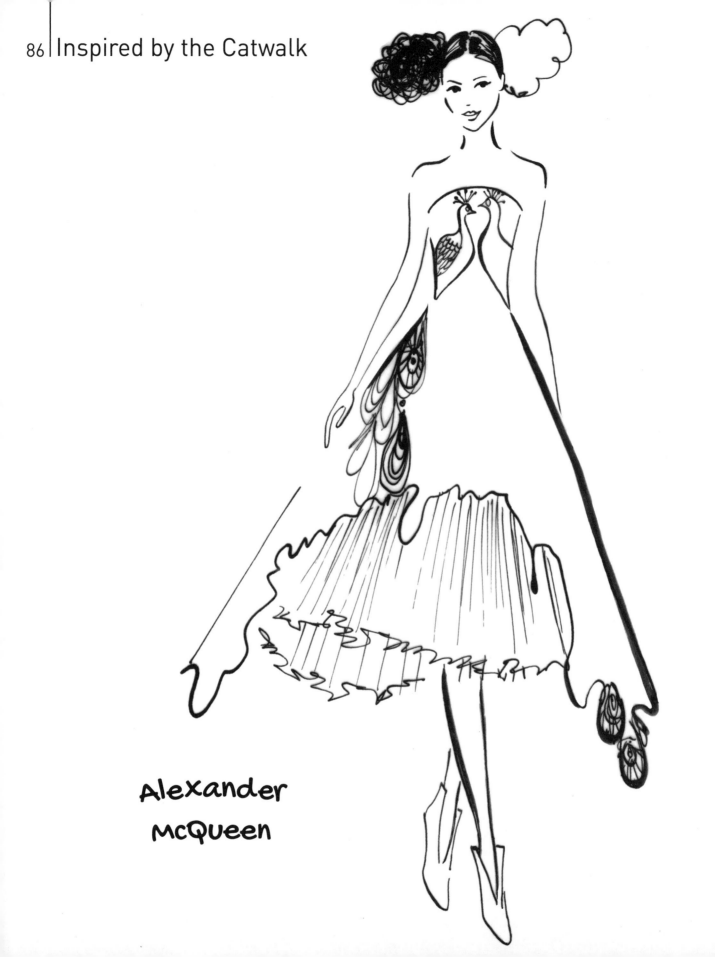

Alexander
McQueen

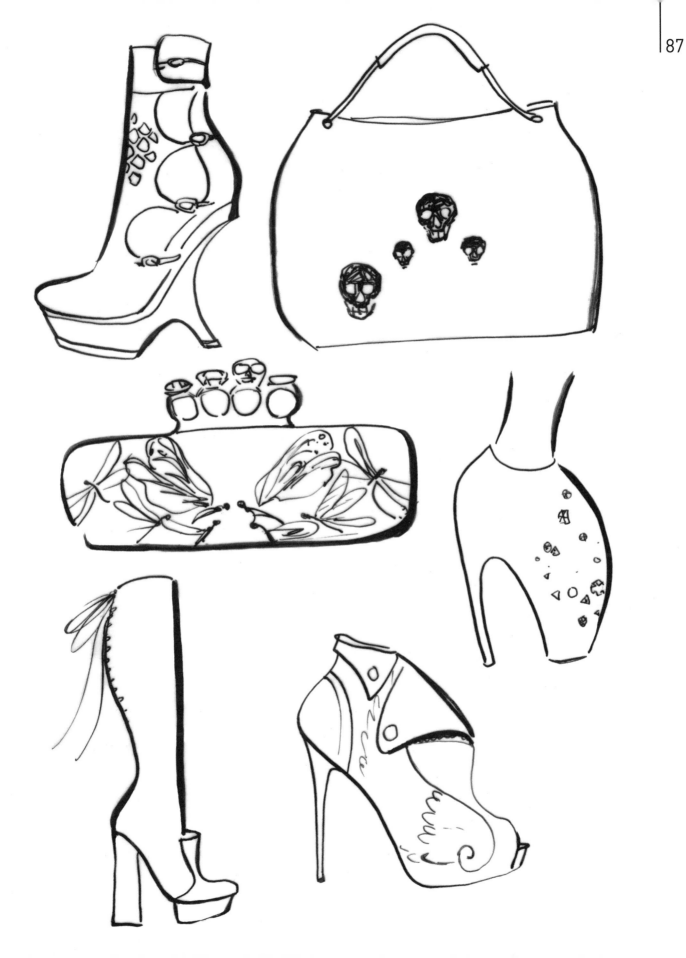

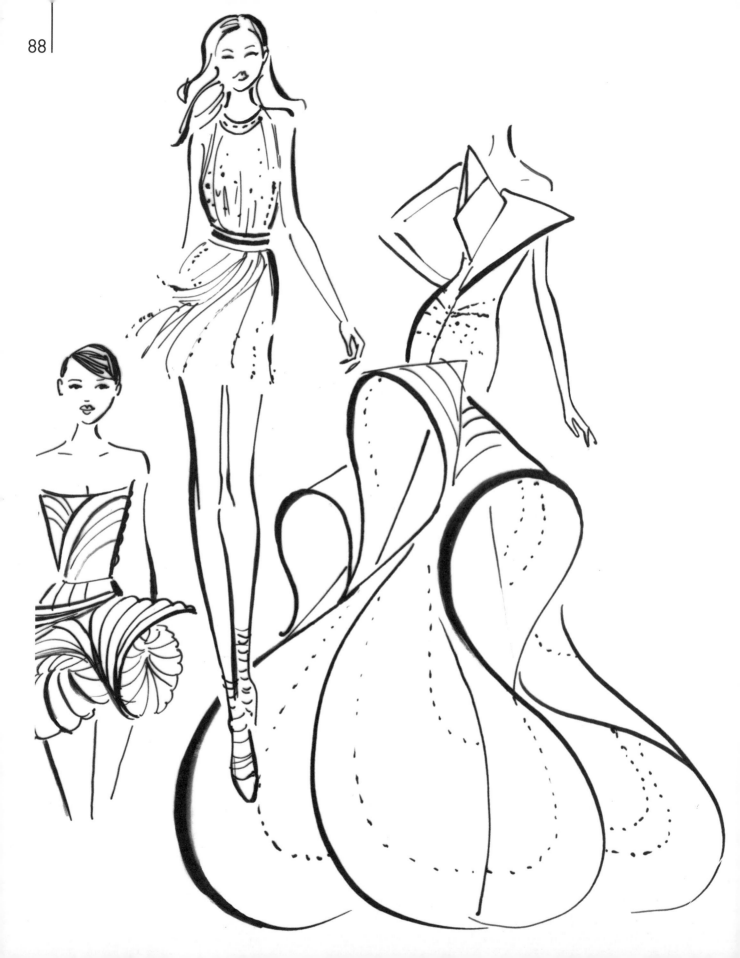

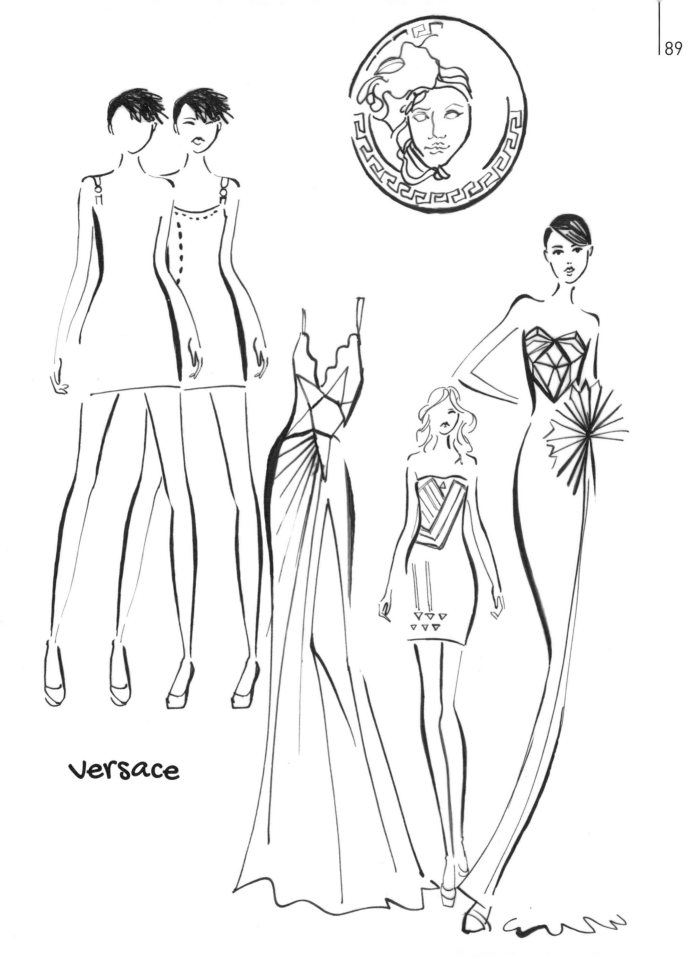

Versace

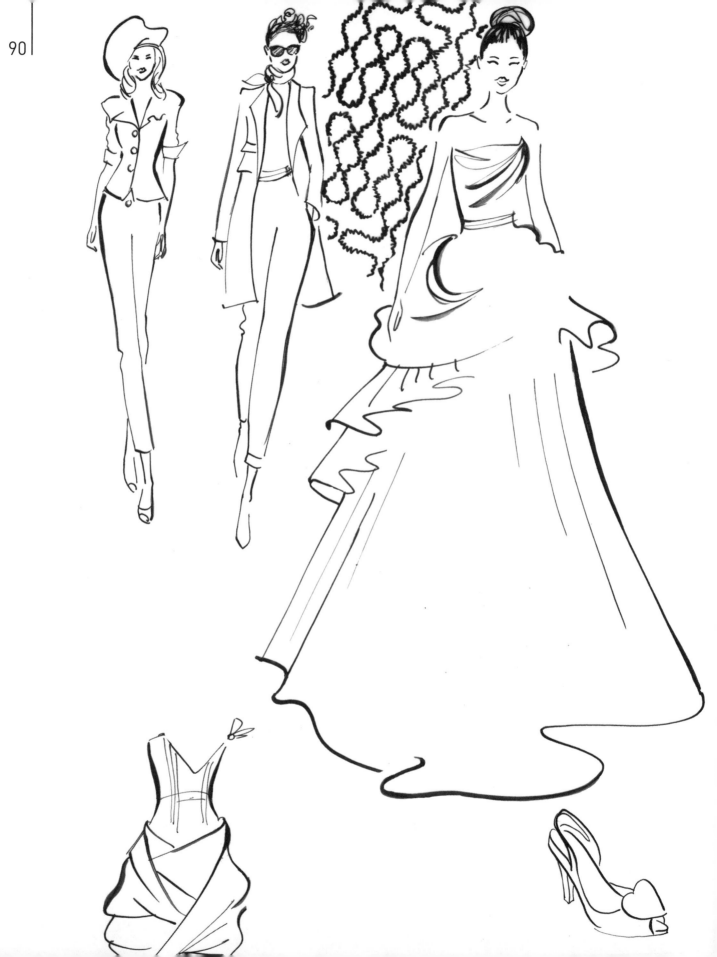

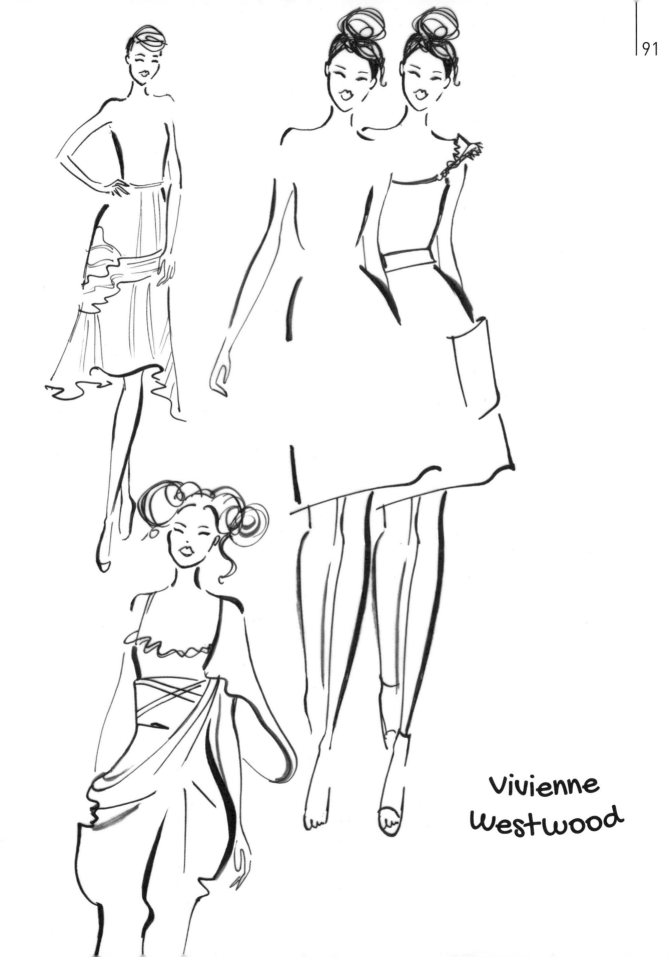

Vivienne
Westwood

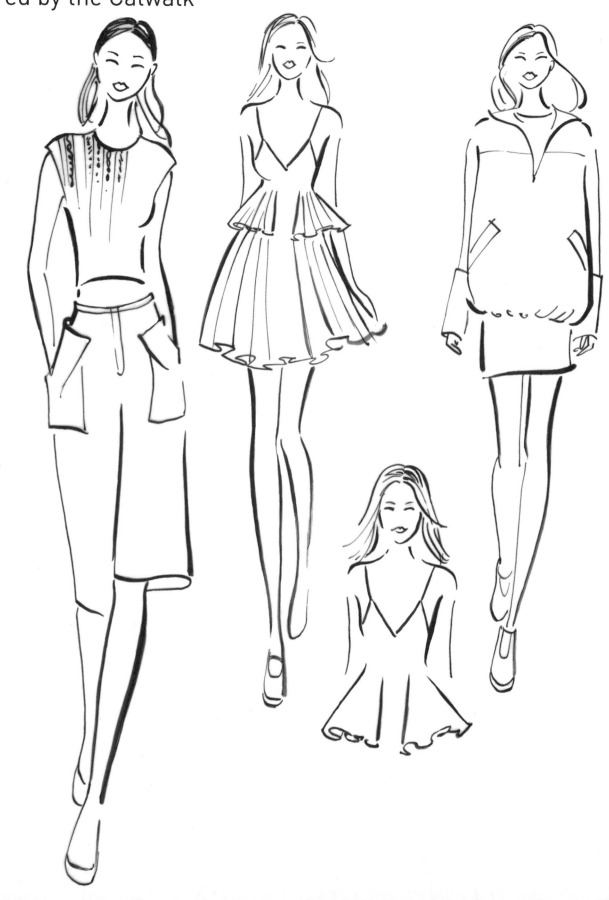

Alexander Wang

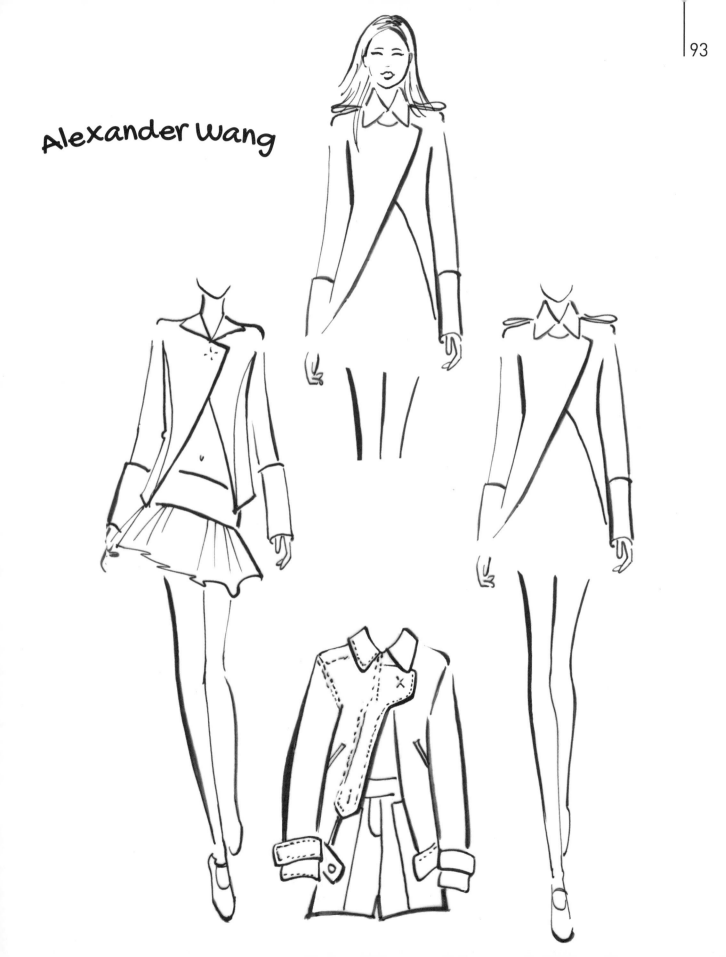

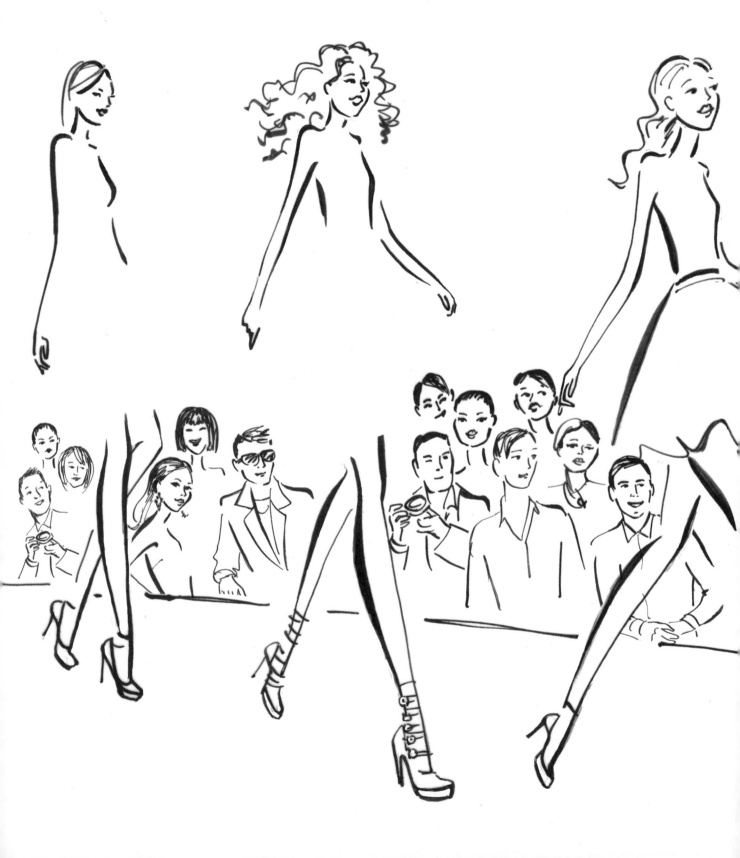

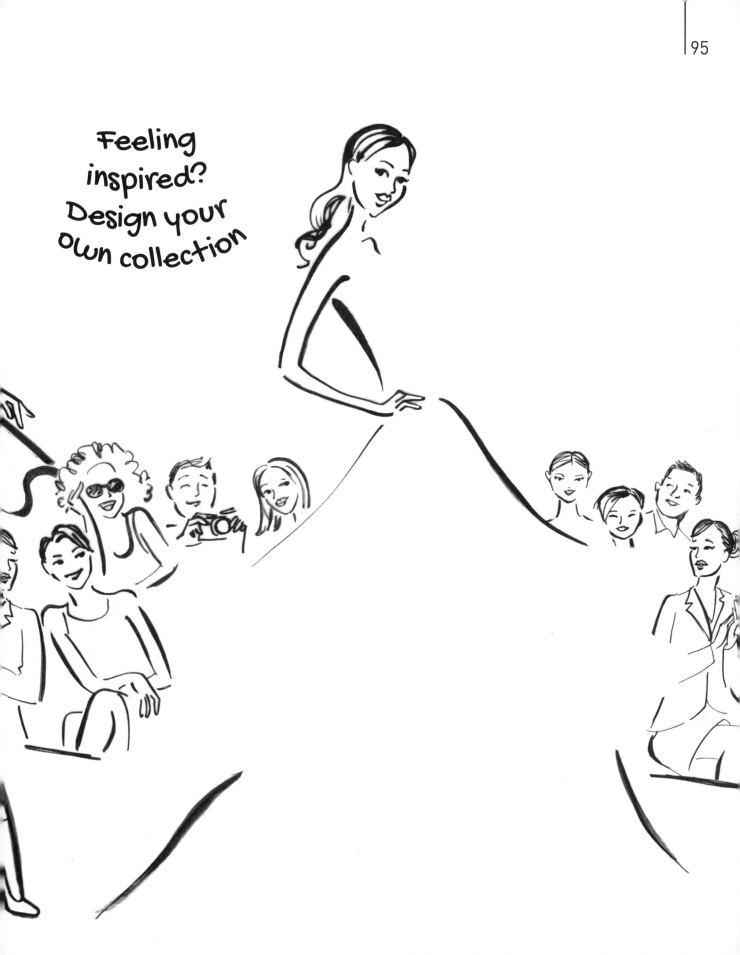

Feeling inspired? Design your own collection

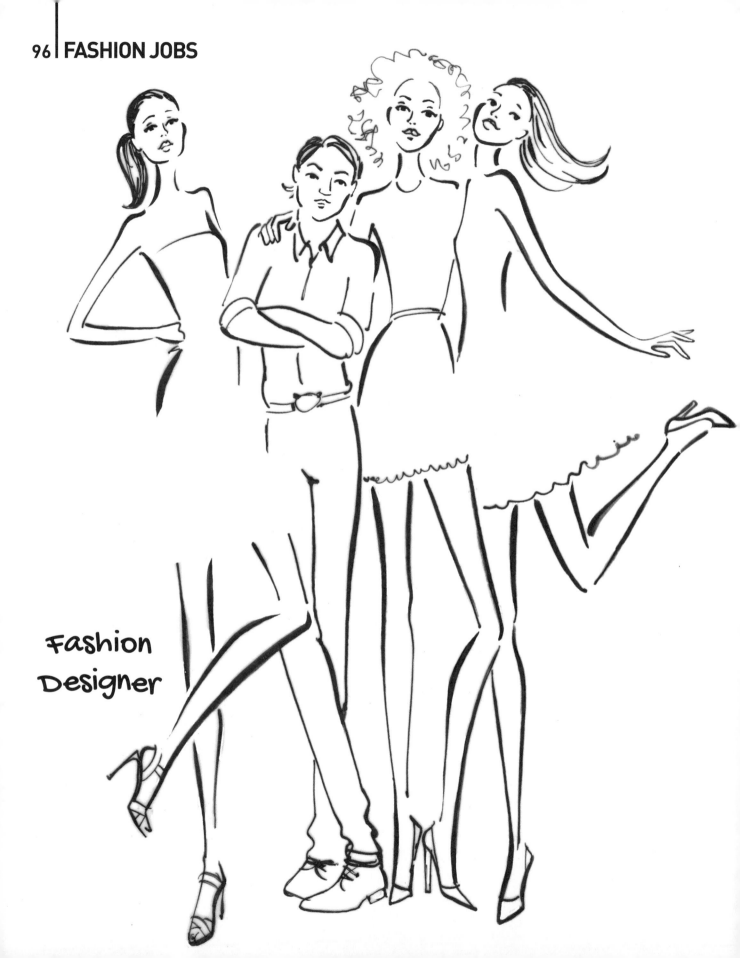

Fashion
Designer

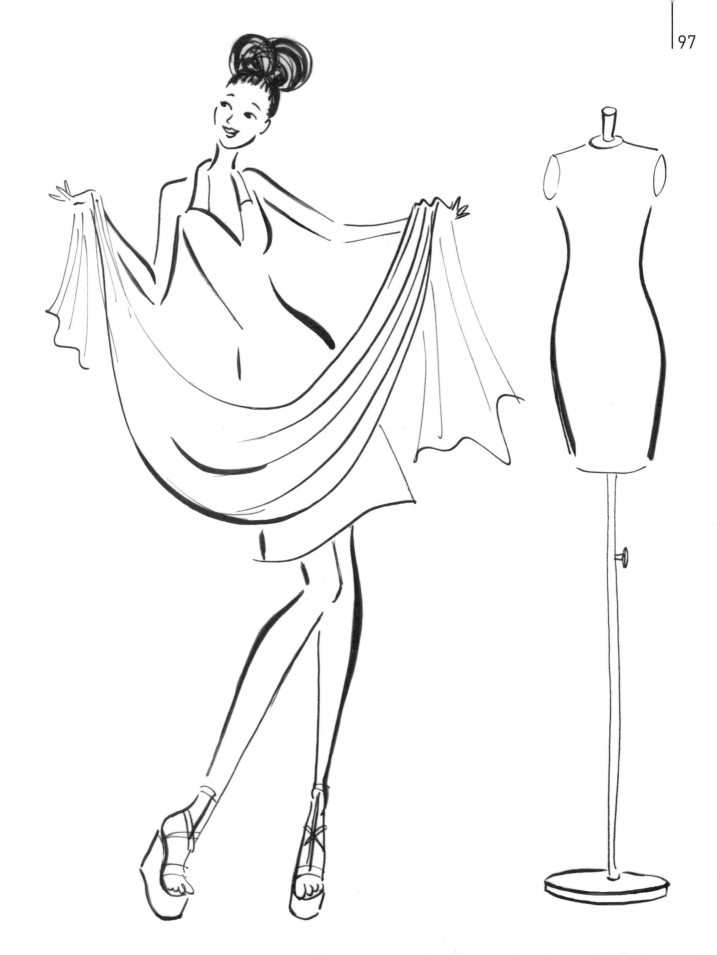

Handbag Designer

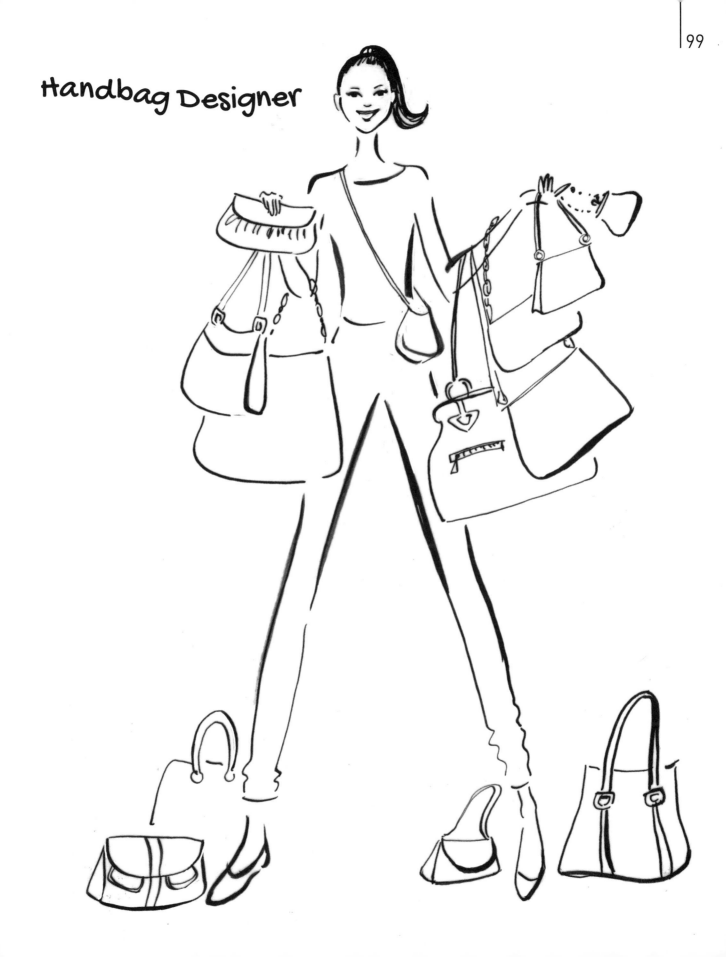

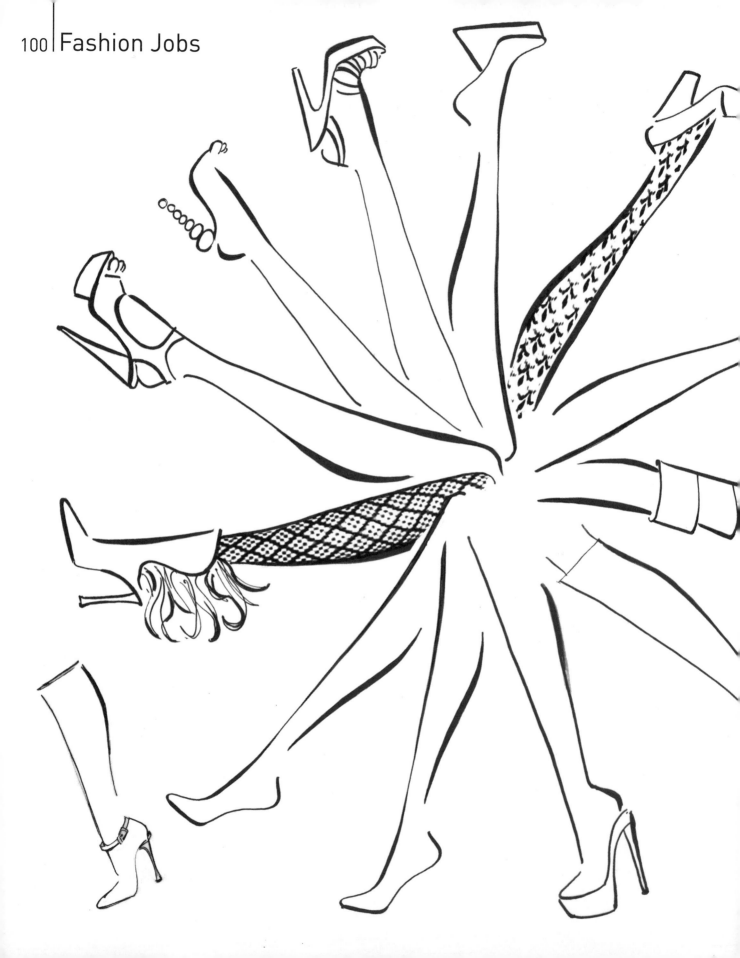

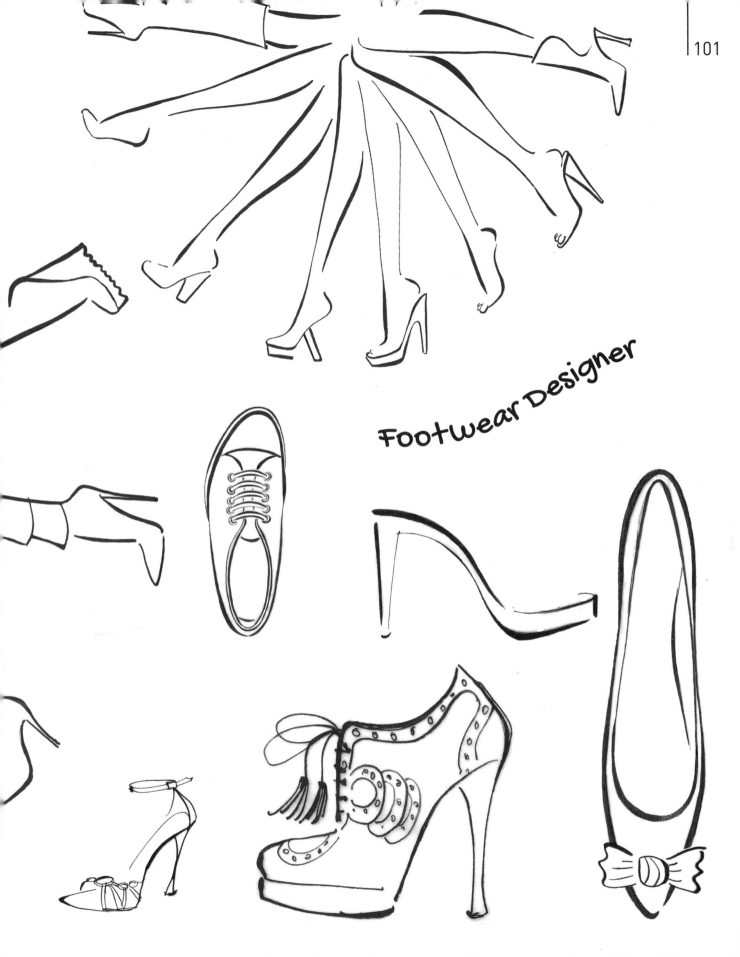

Footwear Designer

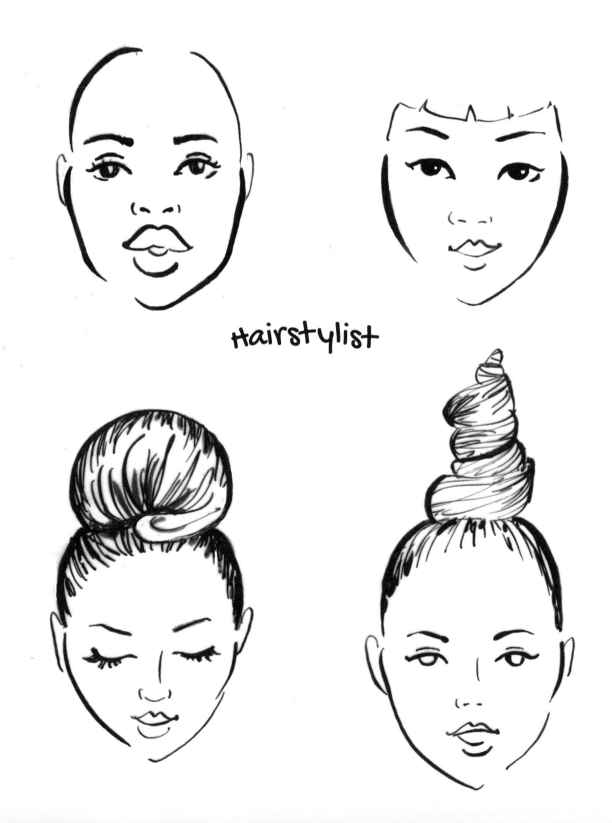

Hairstylist

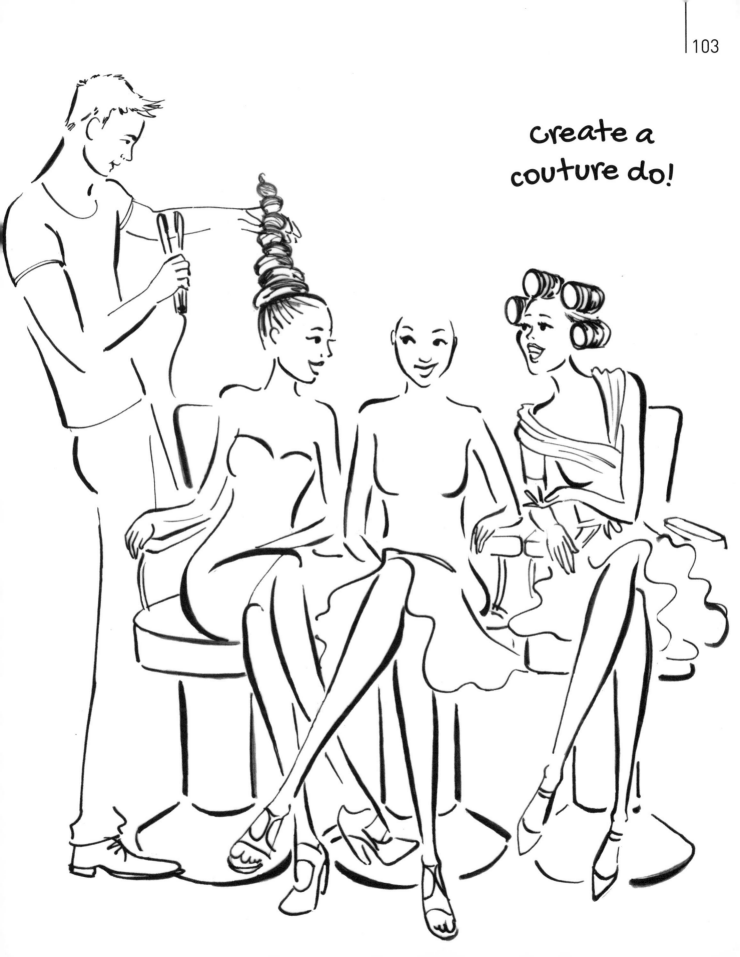

create a couture do!

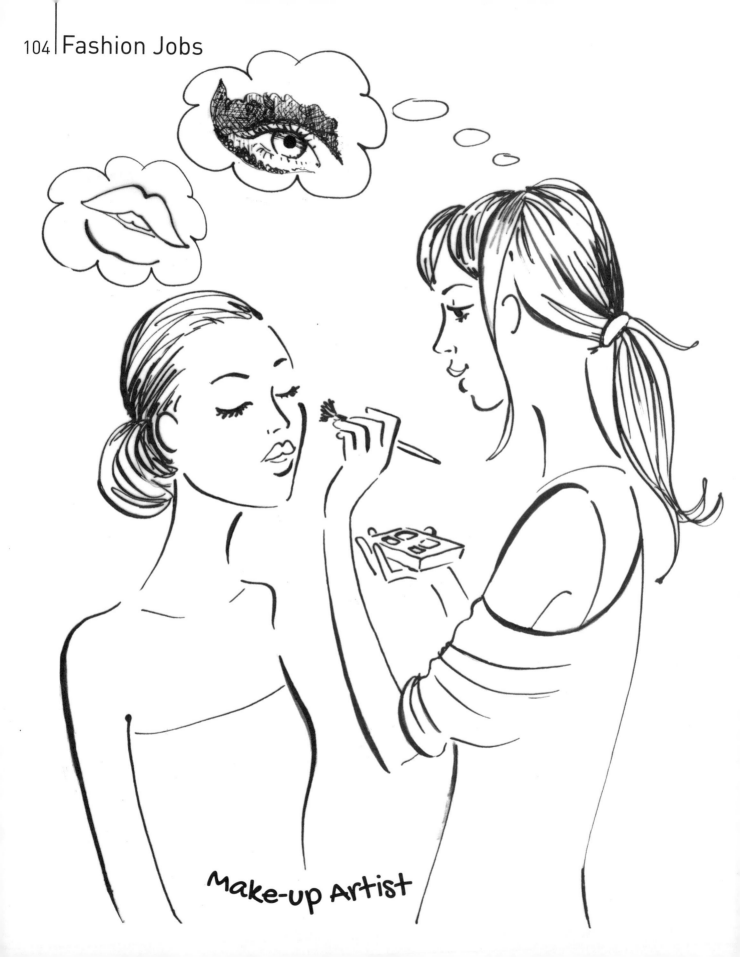

Make-up Artist

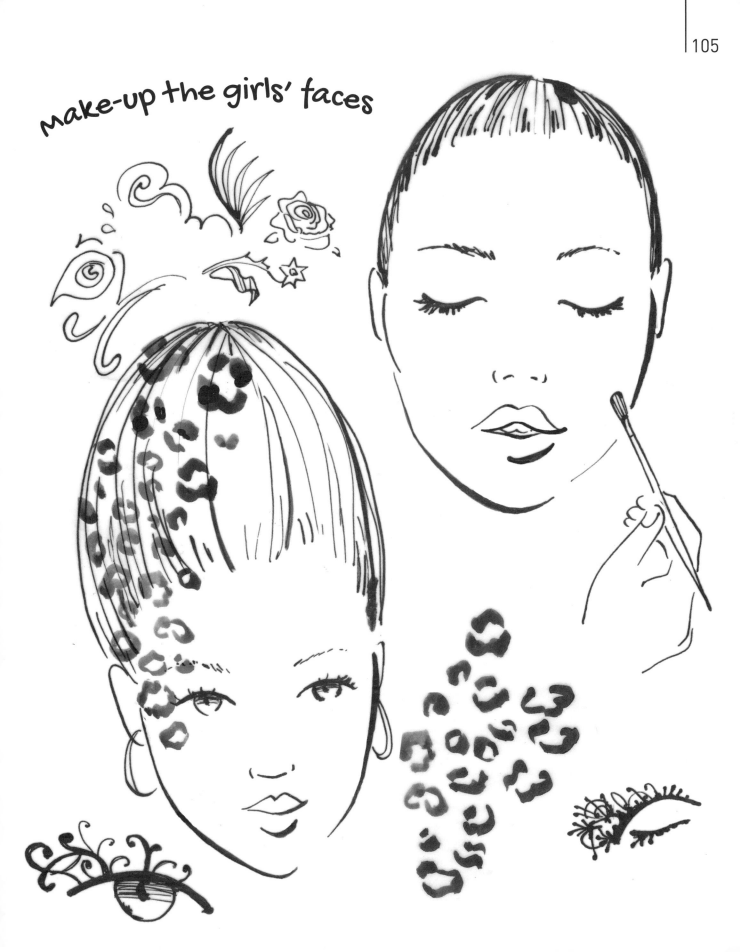

make-up the girls' faces

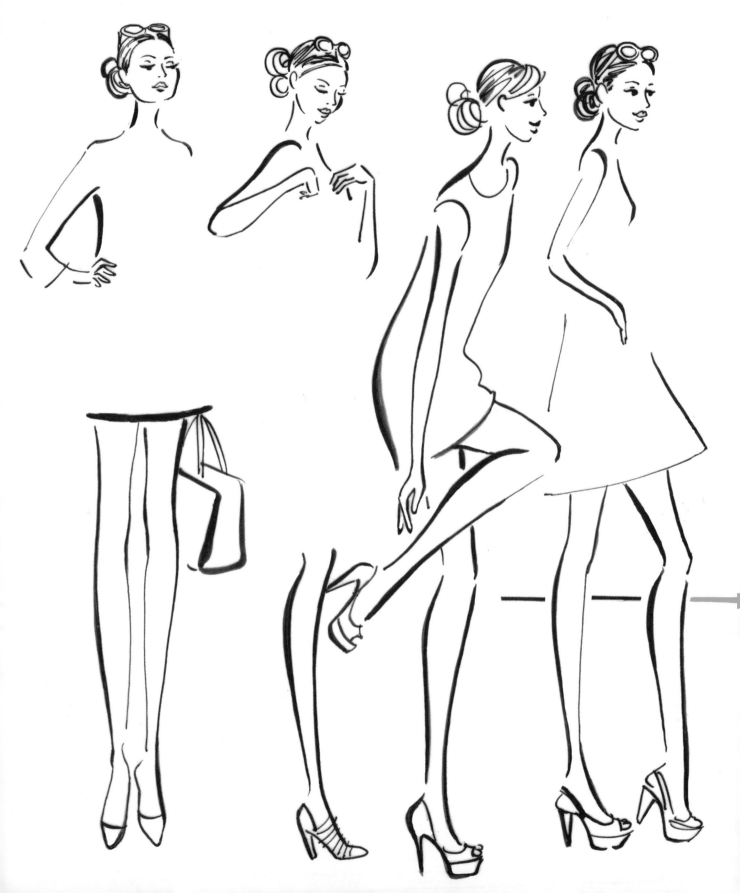

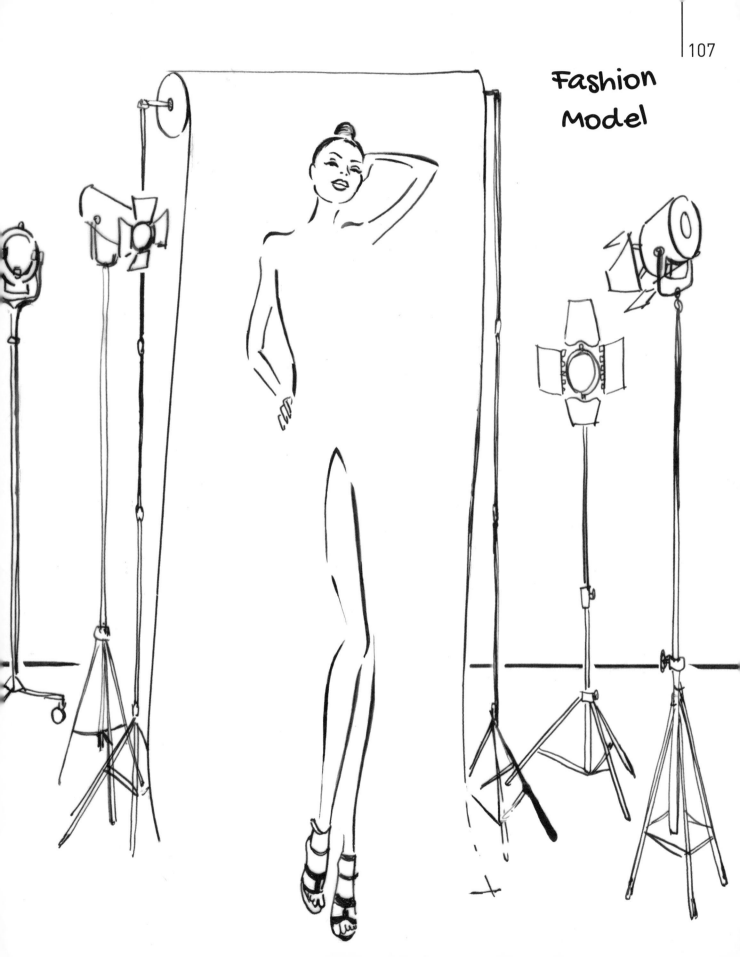

Fashion Model

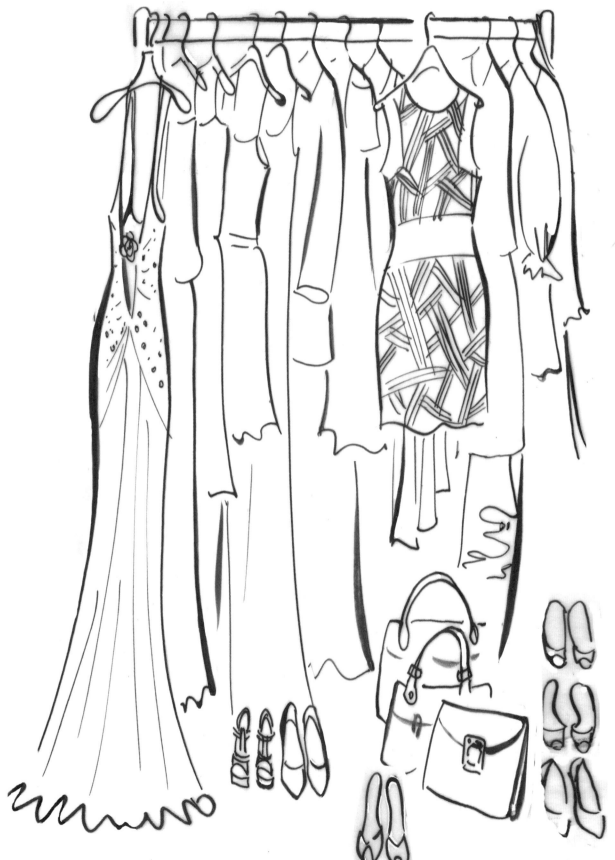

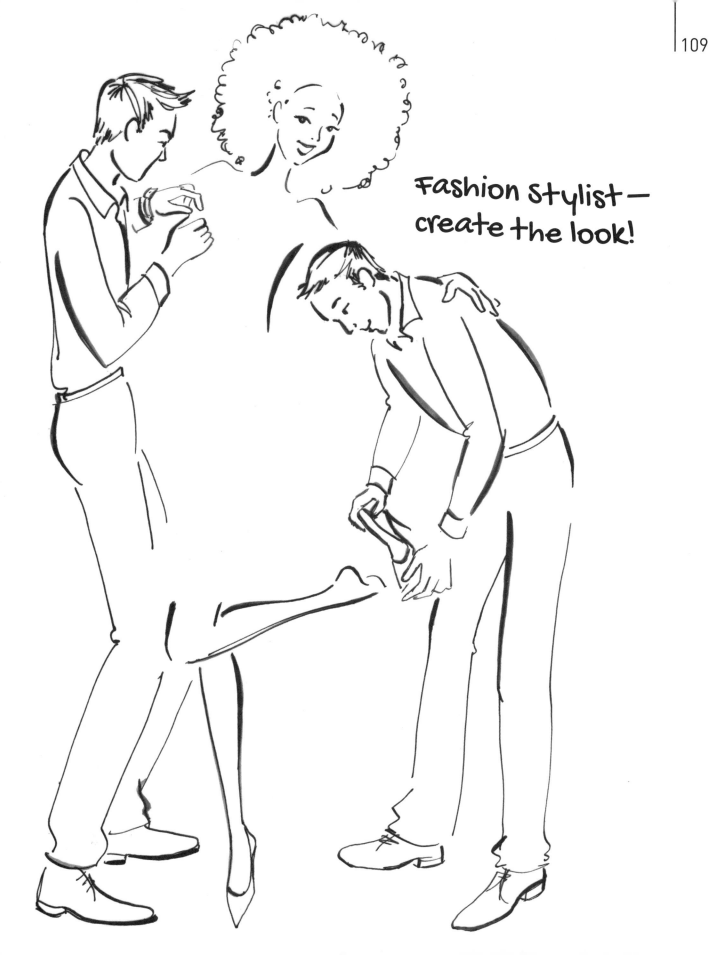

Fashion stylist—
create the look!

What does the Fashion Journalist keep in her cupboard?

Think of some new trends for the Fashion Editor

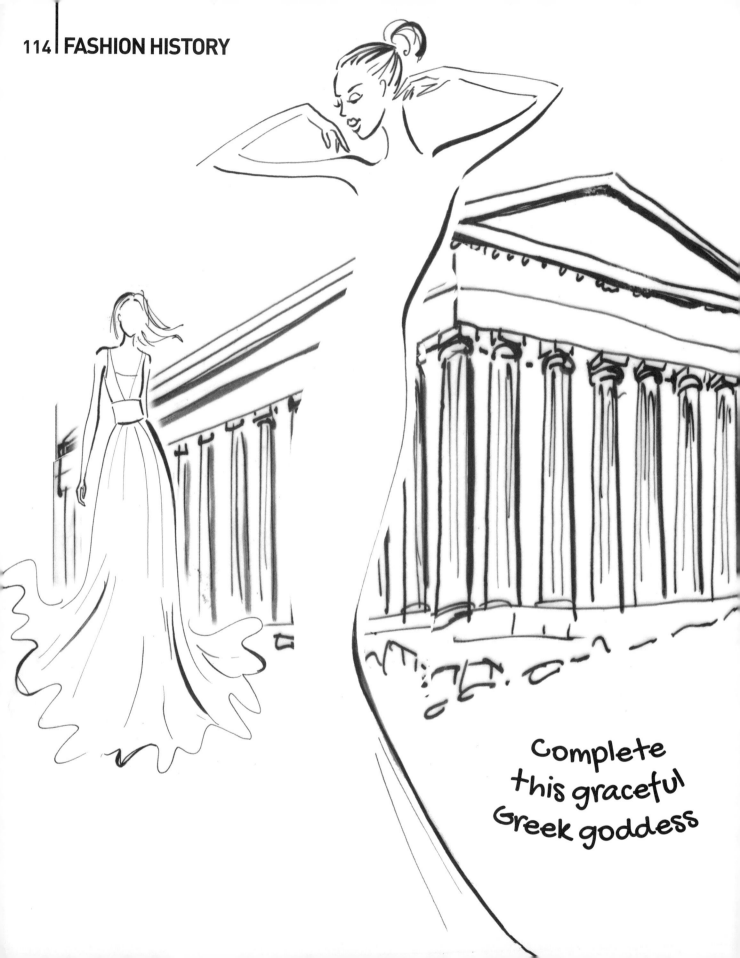

Complete this graceful Greek goddess

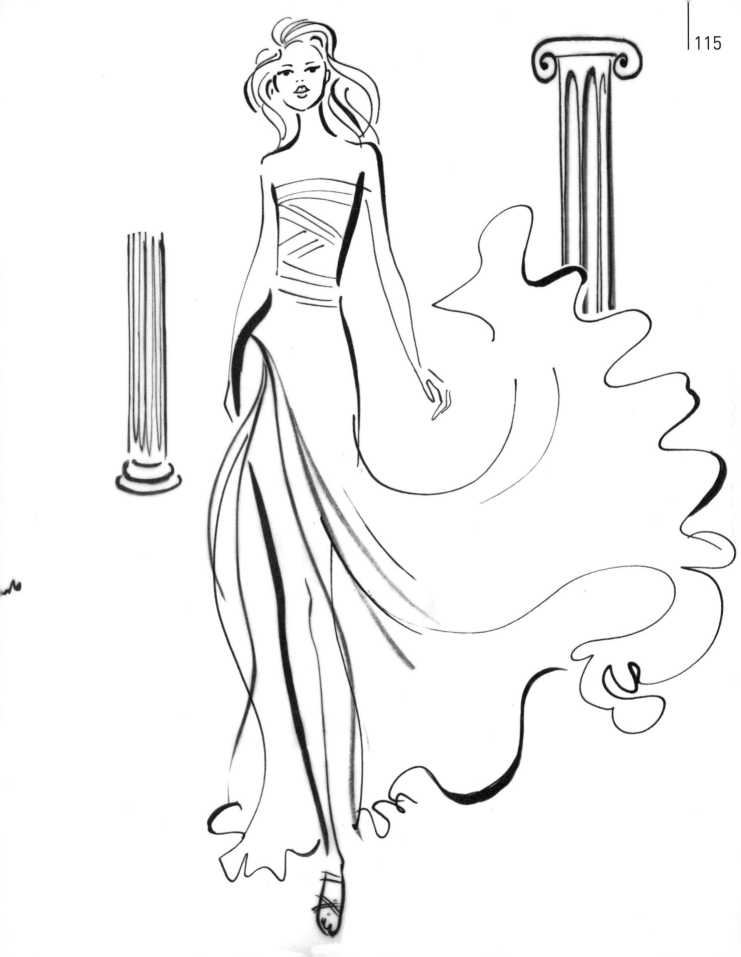

Doodle some 18th-century French fashion

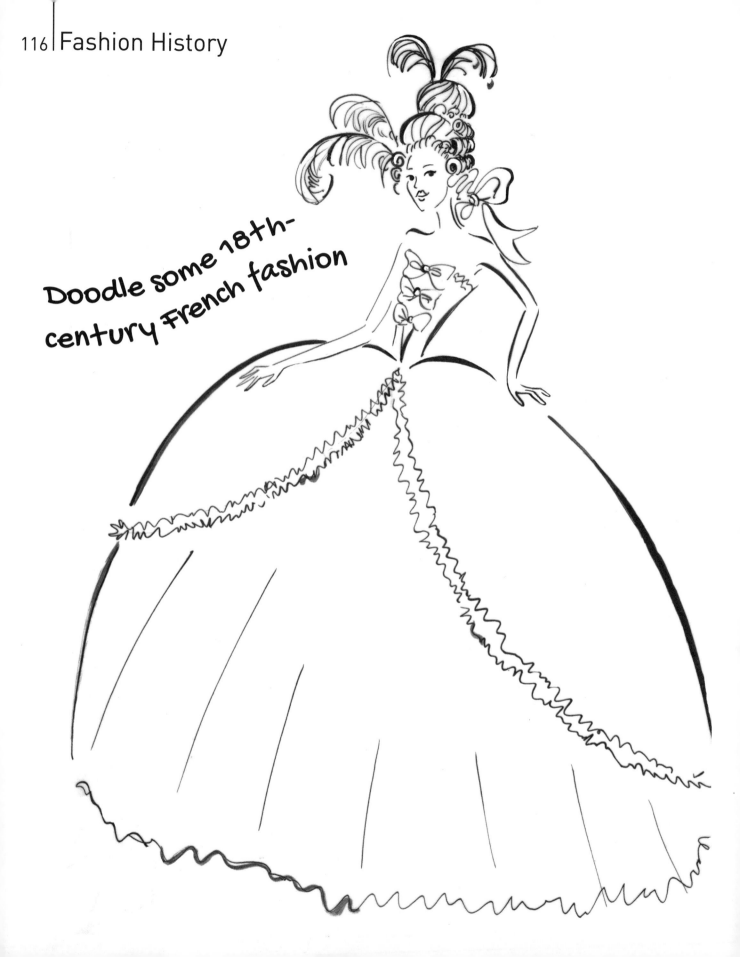

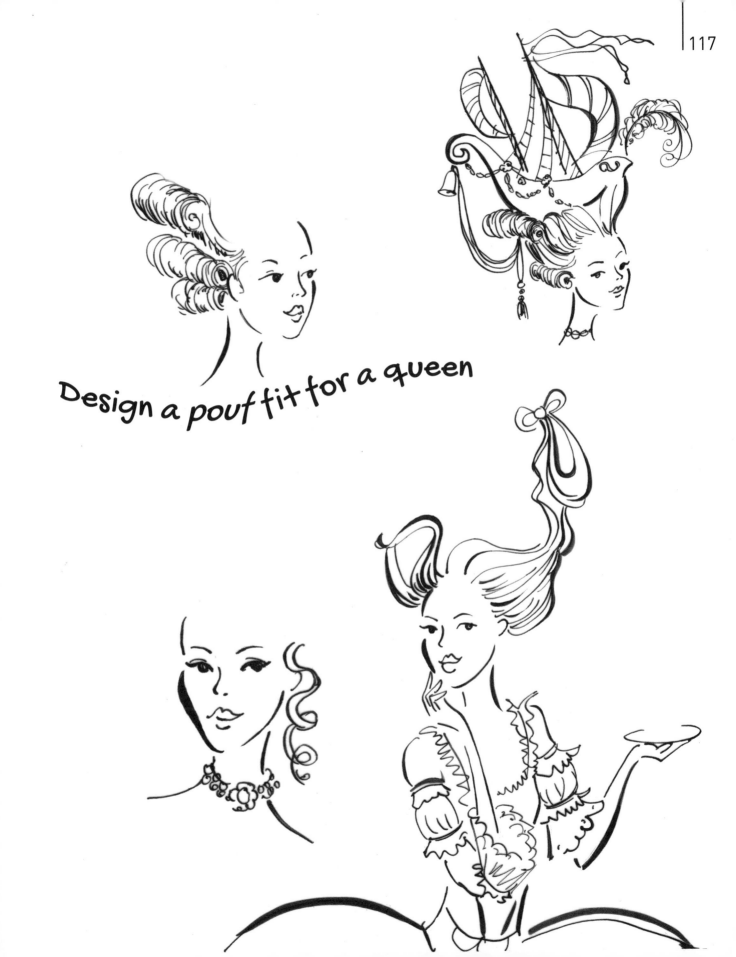

Design a pouf fit for a queen

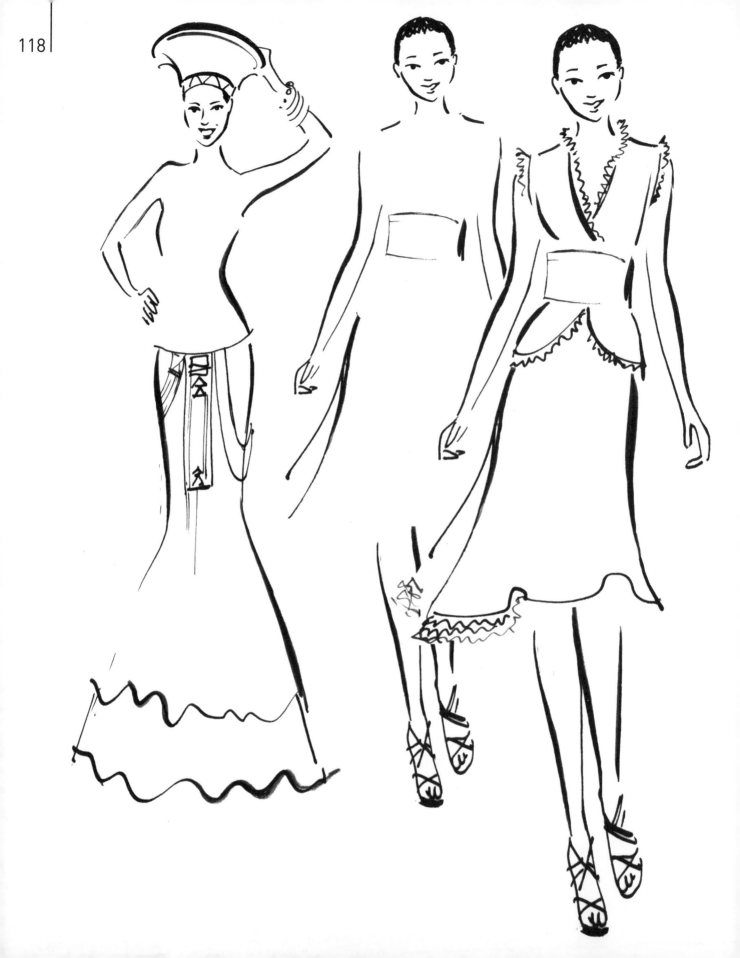

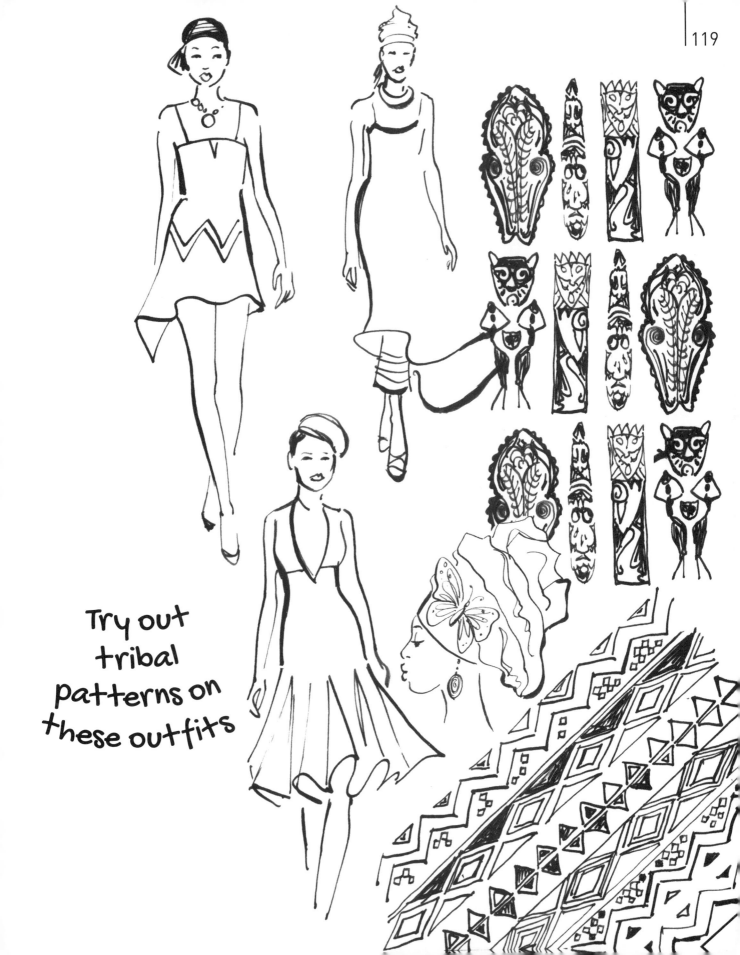

Try out tribal patterns on these outfits

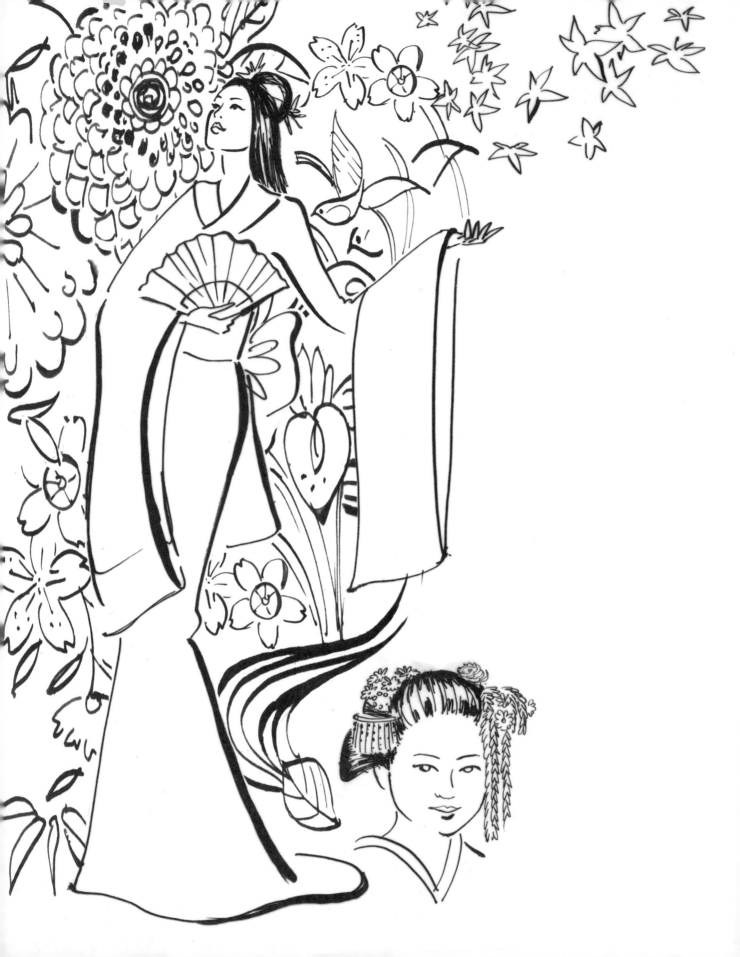

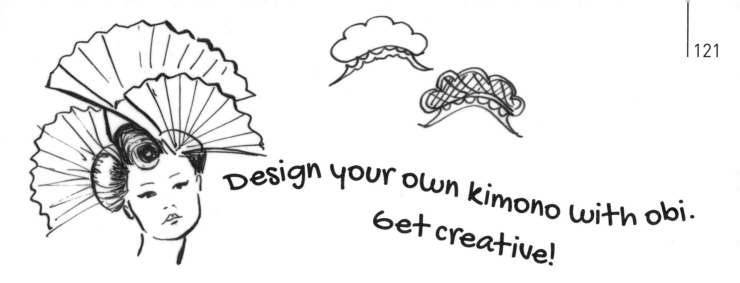

Design your own kimono with obi.
Get creative!

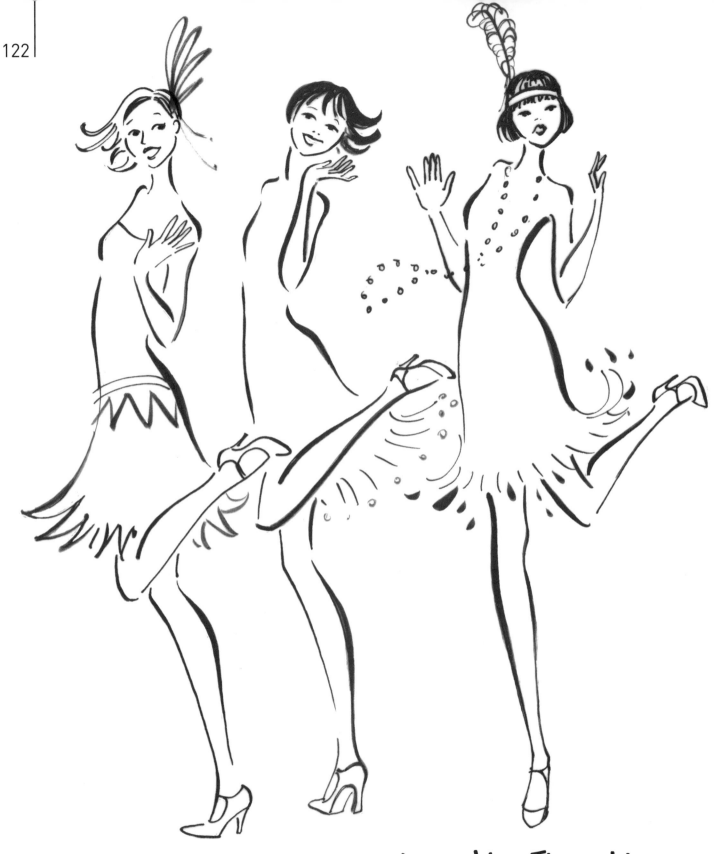

Doodle these flappers from the Twenties

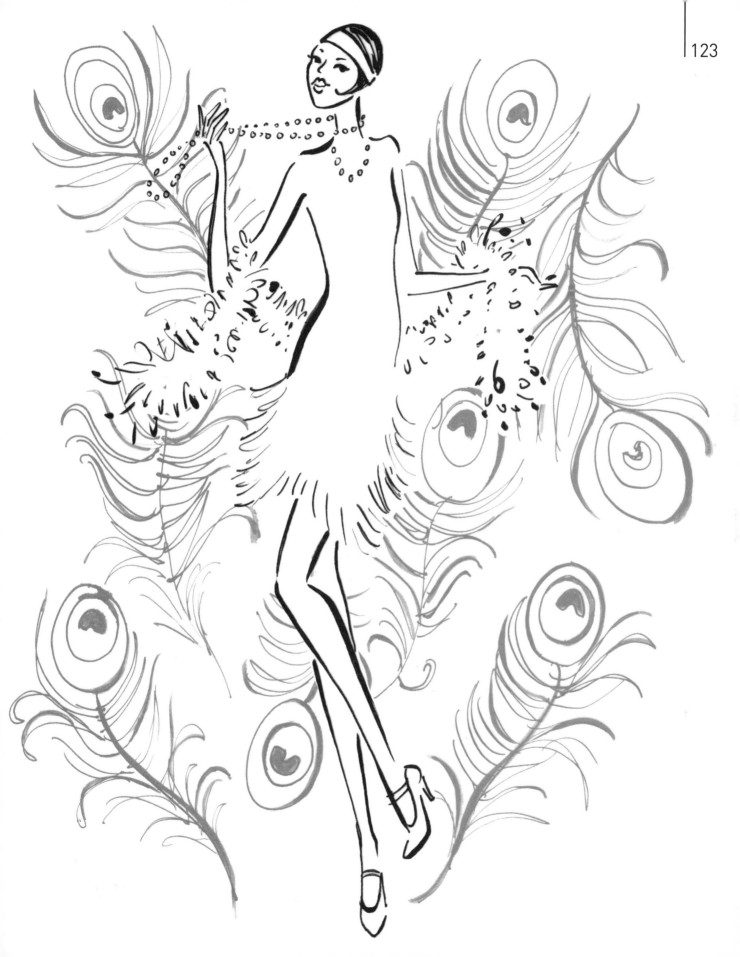

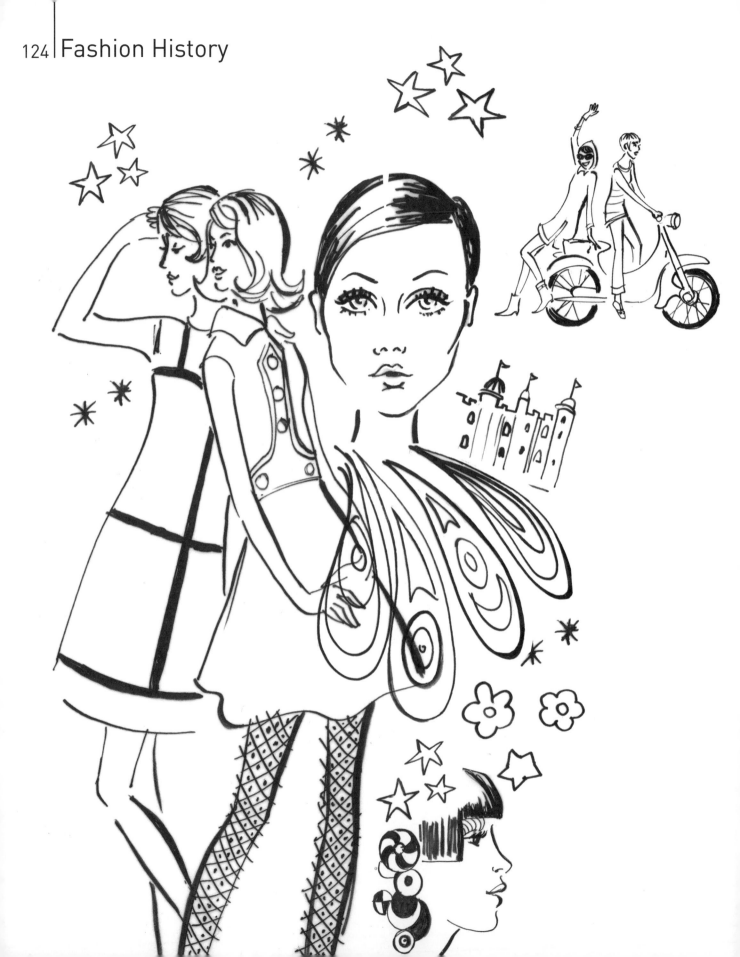

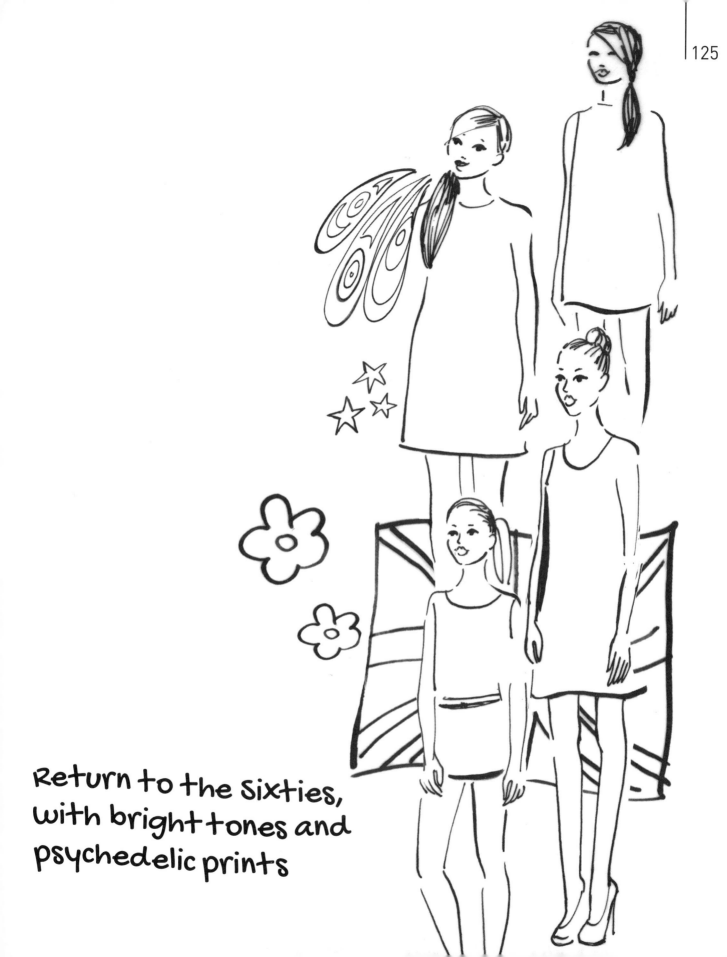

Return to the sixties,
with bright tones and
psychedelic prints

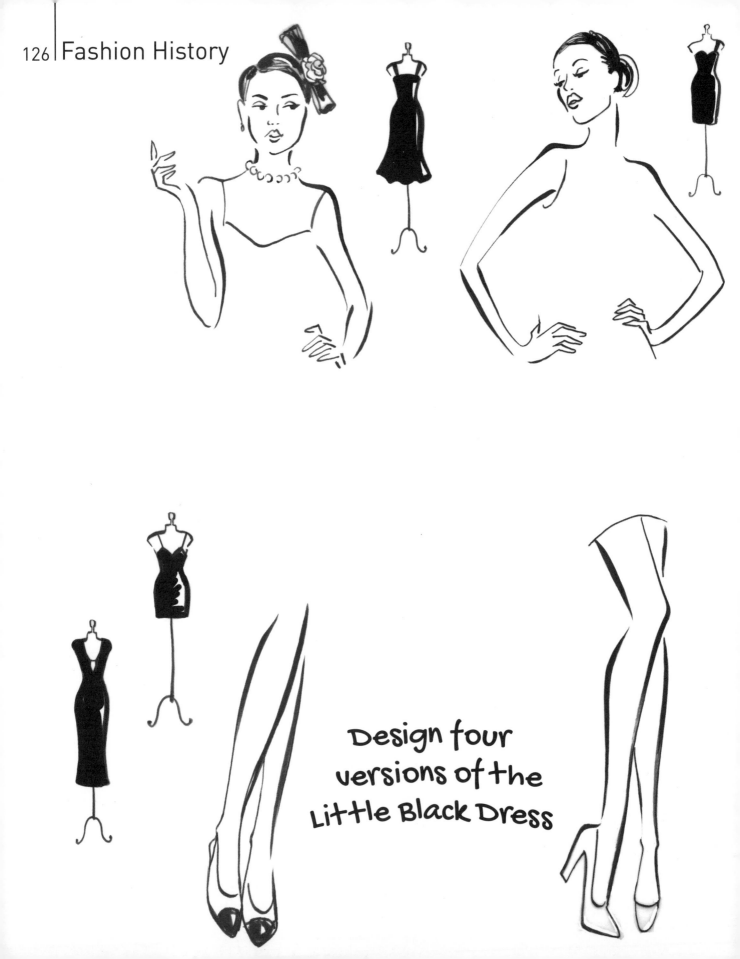

Design four
versions of the
Little Black Dress

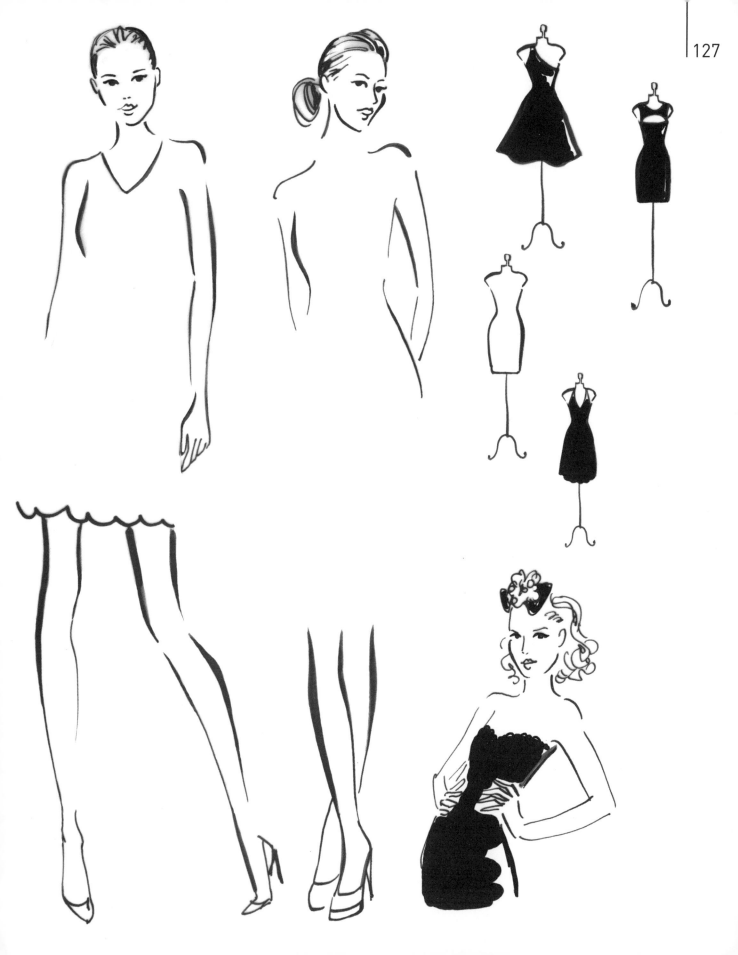

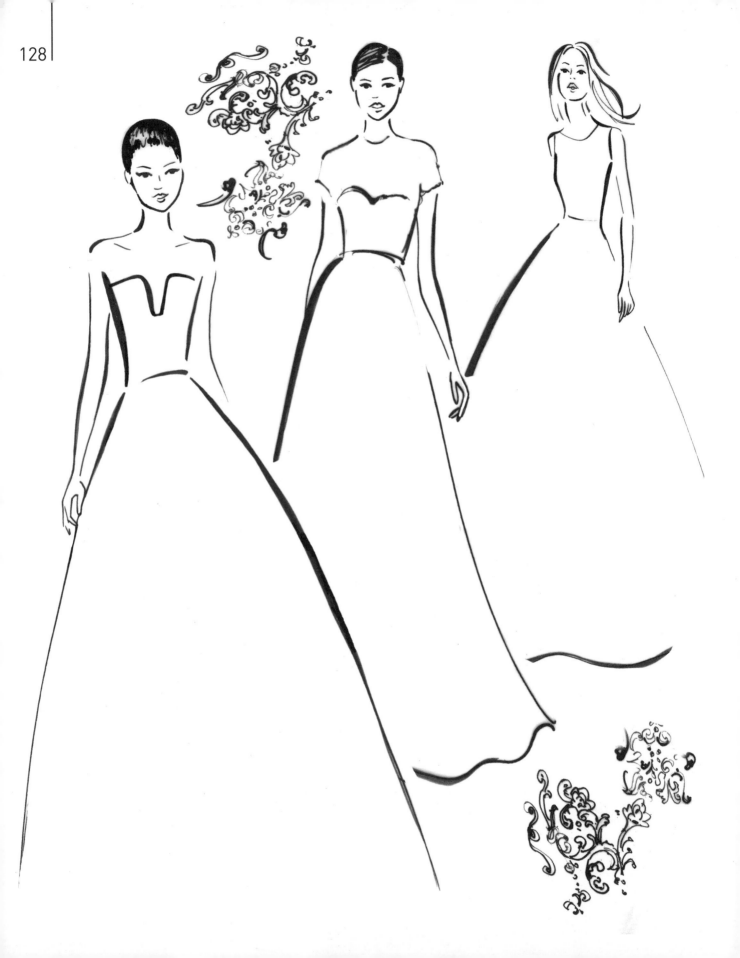